IMAGES
of America

CARIBBEAN AMERICANS
IN NEW YORK CITY
1895–1975

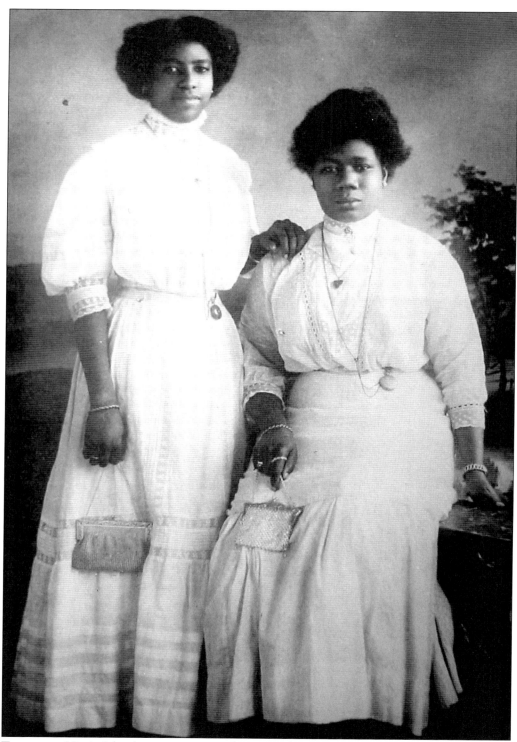
Two young Virgin Island women pose on their arrival at Ellis Island in 1900.

IMAGES
of America

CARIBBEAN AMERICANS IN NEW YORK CITY 1895–1975

F. Donnie Forde

Copyright © 2002 by F. Donnie Forde
ISBN 978-0-7385-1101-6

Published by Arcadia Publishing
Charleston, South Carolina

Printed in the United States of America

Library of Congress Catalog Card Number: 2002108535

For all general information contact Arcadia Publishing at:
Telephone 843-853-2070
Fax 843-853-0044
E-mail sales@arcadiapublishing.com
For customer service and orders:
Toll-Free 1-888-313-2665

Visit us on the Internet at www.arcadiapublishing.com

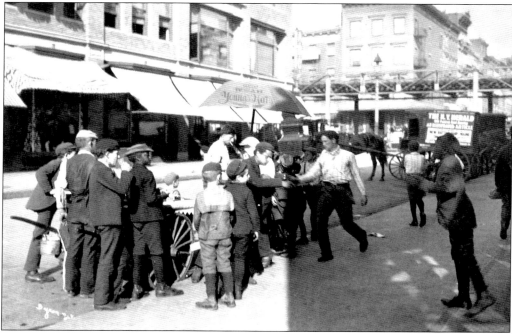

Integration is evident in this 1900 photograph taken at West 36th Street in the section of Manhattan then known as the Tenderloin. The young boys are newspaper peddlers out on a lunch break, apparently just having been remunerated for their labor. The Tenderloin neighborhood, which went from 23rd Street to 42nd Street west of 6th Avenue, was primarily populated by poor Irish and Germans in the early 20th century, with a significant black presence. In later years, after the blacks departed for elsewhere, the designation was changed to Hell's Kitchen.

CONTENTS

Acknowledgments		6
Introduction		7
1.	Neighborhoods	9
2.	Civil Rights	33
3.	Pursuits	47
4.	Housing	61
5.	Education	75
6.	Religion	87
7.	Leisure	97
8.	Portraits	109

ACKNOWLEDGMENTS

The author would like to express his appreciation to the following institutions and agencies for their contributions toward this endeavor: mid-Manhattan branch of the New York Public Library, Schomburg Research Center of the New York Public Library, Fordham branch of the New York Public Library, Brooklyn Division of the Brooklyn Public Library, Long Island Division of the Queens Borough Public Library, Bronx County Historical Society, Brooklyn Restoration Corporation, Roman Catholic Black Ministry of Manhattan, Roman Catholic Black Ministry of Brooklyn-Queens, Episcopal Diocese of Queens-Brooklyn, Hanson Place Methodist Church, Hanson Place Seventh Day Adventist, Weeksville Historical Society, Brooklyn Borough President Office, Queens Borough President Office, Board of Education–High School Division, Brooklyn College–Caribbean Club, York Community College of CUNY, New York University–Africana Studies, New York Technical College of CUNY, York College of CUNY, Polytechnic University, Veteran Administration Hospital, Kings County Hospital, Kingsboro Jewish Hospital, Library at Boys and Girl High School, Library at George Wingate High School, Brooklyn Youth Collective, Daily Challenge, and any institutions inadvertently missed.

The author would also like to extend his gratitude to the following persons for their assistance: Simon Alicea, Norris Archibald, Allison Babbs, Charles Bailou, John Baynes, John Brathwaite, Rev. Martin Carter, Duane Chandler, Carol Chen, Fr. Peter Colapietro, Tyrone Davis, Lance Forbes, Rev. Mary Hough, John Hyslop, Ms. E. Israel, Hollis Jenkins, Edna Jordan, Catherine Kirk, Fr. Jim Krische, Ms. A. Layne, Mark Levine, Leslie Lewis, Dawn Martin, Joan Maynard, Rev. Patrick Perrin, Felicia Persaud, Lem Peterkin, Eric Pryor, Mahmud Ramza, David Singh, Philip St. Prix, Fr. Andres Struzzieri, Duncan Turner, and all those persons inadvertently missed.

Special thanks go to Ivan L. Forde, who made this effort possible through his generosity.

Of the many sources consulted in this endeavor, the author found the following especially helpful: *A Ghetto Grows in Brooklyn*, Harold X. Connolly; *Emerging Neighborhoods*, Eleanor Schoenbaum; *We're Still Here*, Jill Jonnes; *Harlem: The Making of a Ghetto*, Gilbert Osofsky; *Blood Relations*, Irma Watkins-Owens; *Long Island Press*; *Newsday*; *New York Times*; *Amsterdam News*; and *Daily News*.

INTRODUCTION

The West Indian presence in the United States is almost as old as the nation itself. Avid students of American history are made aware of this through the papers of Peter Stuyvesant—who, in taking up his post as the governor of *Nieuw Amsterdam* (eventually New York) in 1656—was accompanied by several black natives of Curacao, the Dutch East India colony in the southeastern Caribbean. These blacks, freedmen who served in a number of positions commensurate in pay and status to their white counterparts, settled in Manhattan and later in Brooklyn. They, in turn, were followed by other blacks from the various European West Indian colonies, some of whom continued on to the other large northeastern cities of Boston and Philadelphia. However, not all of those migrating from the Caribbean were black. Indeed, some were white of colonial birth—mostly the progeny of the planters and the plantation overseers. Although most have been missed by the spotlight of history, one notable exception is Alexander Hamilton, the first secretary of the U.S. Department of the Treasury. Hamilton was born of Scottish parents on the tiny Caribbean island of Nevis.

The period also bore witness to the establishment of the republic of Haiti, from which many of its newly liberated countrymen would travel to mainland America as freedmen, mostly settling in the French colony of Louisiana—eventually to become an American state. These black settlers were allowed to participate in the everyday lives of their respective societies—whether North or South—free of legal constraints, even if they were considered to be on a lower social level than their white counterparts. In this climate, Samuel Fraunces, a black immigrant from the island of Martinique, was able to thrive as a New York caterer. In the process, Fraunces contributed a footnote to history—it was in his tavern that the agency later known as the New York Chamber of Commerce was organized, and it was there that the victorious Gen. George Washington bade farewell to his officers.

Although it is true that these early black settlers played a part in the development of the American society, it was a small one. In truth of fact, communal life for the black immigrant West Indian never took roots until sometime after the American Civil War. Around that time, the progeny of the black slaves who had followed their vanquished Royalist masters into forced exile in the Bahamas began immigrating to the United States. They settled along the coast of Florida and the Carolinas, and many eventually found their way to the large northeastern cities, including New York. Paralleling their immigration were many English, French, and Dutch colonial subjects from the Caribbean isles who were seizing the opportunity to fill the employment void created by the emancipation of American slaves and the decimation of the white labor force by the Civil War. Although many of these immigrants remained in the South and assimilated into the local populations, others migrated north to the big industrial cities, where they blended inconspicuously into the black communities. In *Harlem: The Making of a Ghetto* (1963), Harlem historian Gilbert Osofsky noted, "It was not until the Southern and West Indian migrant to New York City [between] 1865-1890 that the negro population actually expanded. . . . By 1900 more than half the negro population [of New York] was born outside the state."

The second wave of West Indian immigration began c. 1900 and continued right up to the Great Depression. By the time it abated in 1930 (due mostly to prohibitive legislation and a decline in labor demands), almost a quarter million West Indians had made their way to the United States, the greater part settling in New York City. Unlike the prior wave of immigrants,

who actually sought assimilation into the black milieu with little attention given to nativism, this latest group insisted on maintaining some semblance of association with their native lands. They settled in traditional black communities (not always by choice) but persisted in creating neighborhoods that were distinctly national or nativist in orientation. This, seen as a provocation, incensed the native American blacks, who viewed the practice as an attempt by the immigrants to distance themselves from them. The result was an acrimonious strife that seriously damaged relations between the immigrant Caribbean and black American communities for many years. It took the emergence of the American-born generation of the immigrants to begin the healing process, and this was not always done with the keenest of consideration for the later immigrants.

By 1965, new laws enacted by the Johnson administration again opened up the floodgate to Caribbean immigration. This wave also included large numbers of Haitians (the majority arriving as refugees) and, for the first time, significant numbers of Caribbeans of East Indian extraction, mostly from the former British colonies of Trinidad and Guyana. Most of the new immigrants, however, arrived from Jamaica. Less educated and generally of a lower social calibre than their earlier compatriots, they nonetheless showed a greater inclination to forging a common cause with the native black Americans, undoubtedly influenced by the charismatic reggae populist Bob Marley. On the other hand, the Haitians, like earlier Caribbean immigrants, formed distinct Haitian communities while carefully crafting alliances with other black groups. Both of these groups showed a propensity for suburban living, many choosing the outlying districts of Queens and Nassau in preference to the more congested boroughs of Manhattan and Brooklyn. Similarly, both have been gravitating toward a tendency to describe themselves as separate entities and have adopted the nomenclature of Indo-Caribbean and Haitian-Americans, respectively, as their ethnic identities.

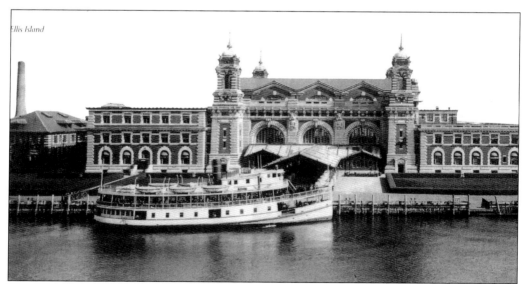

The Ellis Island Customhouse is pictured c. 1900. Between 1892 and 1924, more than 16 million immigrants passed through it. However, not everyone entering the country during this period was processed at Ellis Island. Among those spared the dreaded scrutiny were some sponsorees, but those who were forced to undergo the examination came away with varied experiences. Lyle Small was dispatched after a few perfunctory questions. Former advertising executive Viola Lewis Scott was sent back to Barbados as a 10-year-old after she was discovered to have ringworm.

One

NEIGHBORHOODS

At the beginning of the 20th century, it was difficult to determine black neighborhoods by their ethnic or national orientation. One of the reasons for this was that the blacks who lived in the particular neighborhoods were all seen as being Anglophone—whether American born or foreign—given that the overwhelming majority spoke English as their first language. Slavery having ended shortly before this period, ethnicity and nationality had not yet emerged as factors in their social panoply. By the second decade of the 20th century, however, these differences would begin to manifest themselves. Blacks had been recognized not for what they said but for how they spoke. Ultimately, how they spoke became a determining factor in how they were regarded. Increasingly, neighborhoods would be fashioned along the latitudes of class, the wealthiest residing in the areas in which their means allowed them to live. Also, those who were of a particular nationality lived together in somewhat communal settings.

The early-20th-century black neighborhoods of the Tenderloin and San Juan Hill districts in midtown Manhattan were recognized only for the race of people who resided in them. By the 1920s, however, the black community that had been established in Harlem would sprout neighborhoods that would be subtly distinguished as Caribbean because of the predominance of West Indians who resided in them. Such neighborhoods were founded around St. Nicholas Avenue just east of Morningside Heights. Similar neighborhood patterns also existed in central Brooklyn in the Bedford-Stuyvesant district, where large numbers of West Indians had settled before and after World War II. Less conspicuous of these intraracial communities was the confluence of nationalities that composed their character. There may be, for example, one block with a predominance of Barbadians, while the other block may hold large numbers of Jamaicans, and the third may be primarily Trinidadians. Therefore, within a black community, you may find a West Indian neighborhood that is further subdivided by nativity. This is conspicuously less evident in Crown Heights, the district that has evolved into a Caribbean bastion in the last three decades. The change in attitudes toward nationality and nativism has been credited with this organization, but perhaps that is too simple an explanation.

In the Bronx and Queens, group patterns did not develop until later on. The West Indians who first settled in the Bronx were generally employed at the lowest level of the labor market. They worked as maids, custodians, porters, and factory laborers and were compelled by their circumstance to live in the older Mott Haven and Morrisania districts. These areas had the advantage of being just a stone's throw away from Manhattan, from whence most had come, and were also more within line of their economies. Their situation, understandably, did not allow for the luxury of choice, and most contented themselves to a socially disparate existence, coming together infrequently and usually on their sabbaths under the auspices of their churches. By the 1960s, however, most of that changed with the movement of large numbers of West Indians to the suburban-oriented North Bronx in the Wakefield and Baychester districts. Queens also experienced a surge of Caribbeans in the 1960s and 1970s, but many came from overseas, mostly Haitian refugees and Guyanese Indian expatriates. They, too, settled mostly in the South Jamaica districts, merging with the older population. The later Guyanese Indians, however, showed a preference for Richmond Hills to the west.

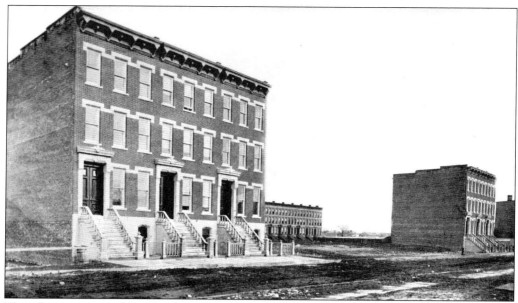

These houses may well be the clue of black Harlem's anatomy. Built upon speculation on West 132nd and 133rd Streets with great hopes for quick occupancy, they nonetheless failed to attract buyers and remained vacant long after completion. In an attempt to recoup his investment, the developer offered the buildings to black realtor Philip A. Payton Jr., who in turn sold and rented them to black home shoppers, thus launching the black migration to Harlem.

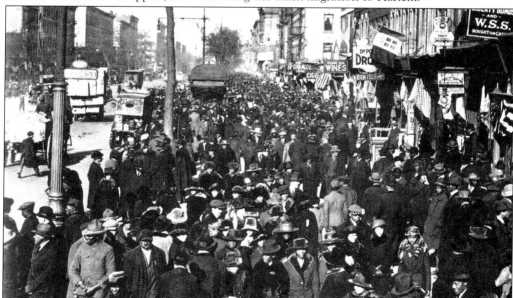

It is hard to believe that so many blacks could be found on any day in Harlem as are shown in this 1919 picture of Armistice Day at Lenox Avenue and 134th and 135th Streets. Given the limitations of intracity travel at the time, one can only speculate that most of them resided there. Yet, it had been only a dozen years since real estate magnate Philip A. Payton Jr. bought some houses on West 132nd Street and rented them to blacks. None other than the eminent scholar James Weldom Johnson would pay tribute to Payton's entrepreneurial genius.

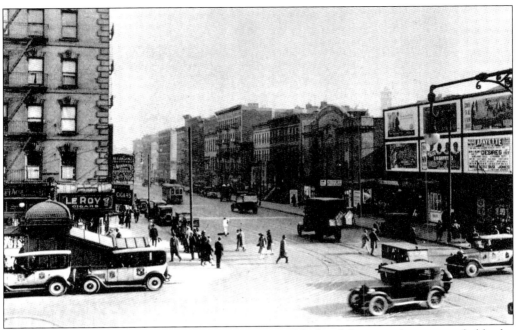

Lenox Avenue at 135th Street is shown in 1927. For blacks of this period, it was probably the most famous intersection in the nation. All of Harlem's blacks were literally crammed into the 60 square blocks that extended from 130th to 145th Streets and from Amsterdam Avenue to Fifth Avenue. During the early settlement of blacks to Harlem, 135th Street was their commercial center but eventually yielded to 125th Street as the merchants began easing their restrictions on black shoppers.

Although Seventh Avenue in Harlem was perhaps more spectacular than Lenox Avenue was, it received less notoriety than its sister street did. Many felt that this had to do with the machinations of white city fathers to limit its usage by blacks in order to protect the white commercial interests that were still holding on in the face of black encroachment. Indeed, many of the famous entertainment establishments and centers abounded there in the early 20th century.

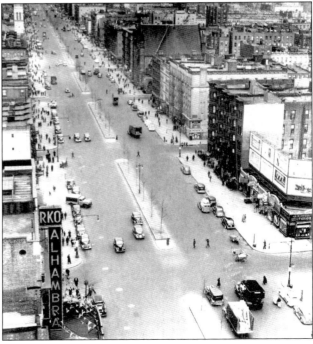

11

As the story goes, it was on the corner of 135th Street and Lenox Avenue that Marcus Garvey struck the chord with his audience that was to lead to his fame as a black nationalist leader. According to Elton Fax (one of his biographers), Garvey, on hearing of the murder of a black man by a white police officer, hurriedly set up his soapbox on the corner and began condemning the police's action. His fiery oratory immediately drew an attentive crowd, which launched his activist career. If you look closely, at the extreme left, you will see the Countee Cullen Library, which is now part of the Schomburg Center.

In 1943, America was fighting a war overseas and on the home front. The children of the earlier immigrants were now young adults and were asking the same question—for what purpose were their brothers and uncles fighting and dying? Some say it was this concern that fueled a minor disturbance into a full-fledged riot. As is usually the case with riots, it was the commercial center that bore the brunt—in this case, Harlem's 125th Street.

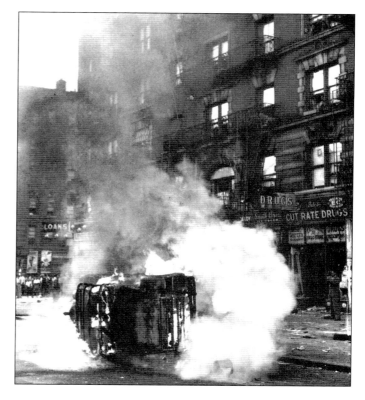

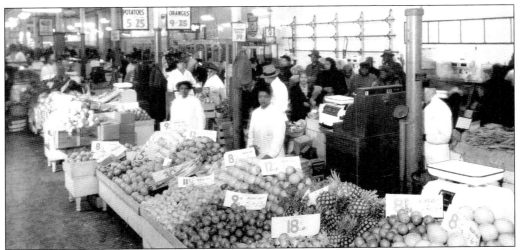

The Park Avenue Market in East Harlem got its name from the street that hosted it. To the Hispanics who patronized it, however, it was *La Marqueta*. To the non-Hispanic Caribbeans, it was the West Indian Market. It specialized in tropical produce that was imported from the islands. Future Congress of Racial Equality director Roy Innis often shopped there with his parents and would occasionally run into future councilwoman Geraldine Daniels. Innis confessed many years later, "I had a crush on her, but she wouldn't give me the time of day."

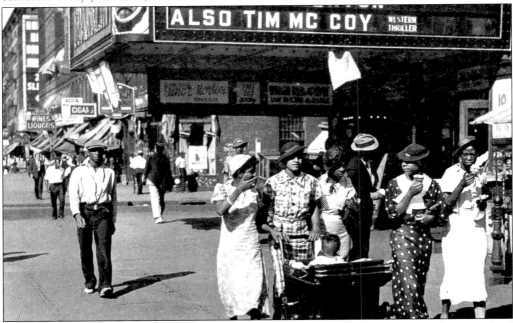

Fed by a constant supply of West Indian immigrants and southern migrants, the growth of Harlem's black population in the first quarter of the 20th century was phenomenal. Harlem had easily become New York City's fastest-growing community. Just three decades after realtor Philip A. Payton Jr. had succeeded in settling the first black family on West 132nd Street (in effect setting in motion Harlem's eventual transition), the community had become almost entirely black. This photograph, taken on Harlem's fabled 125th Street in 1930, shows a scene almost devoid of whites.

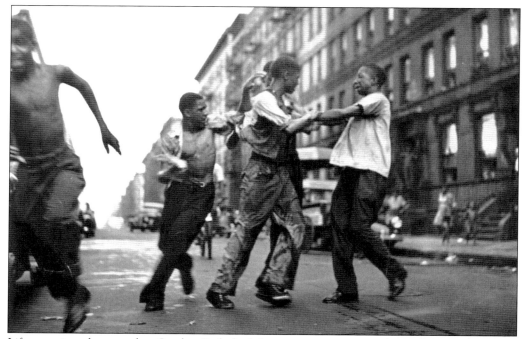

Life magazine photographer Gordon Parks had the uncanny instinct and eyes for a good story. In this view, he captures on film a gang fight by teens on a Harlem street in 1948. By then, Harlem was well on its way to becoming a risky community to rear children. Many of the middle class had already fled to the outer boroughs and suburbs, leaving behind the desperate, the poor, and the committed. In the next two decades, the community would reach a point of crisis.

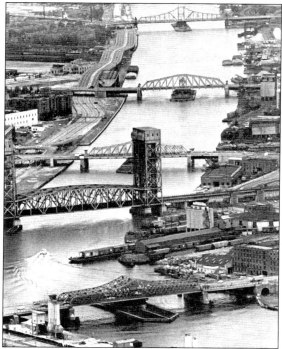

It has been said that few things contributed more to the exodus of blacks from Harlem during the 1930s and 1940s than the construction of the Harlem River bridges. This may be so only as it affected the Bronx. Many of the blacks who lived and worked in Manhattan were now more inclined to purchasing homes in the southern Bronx, knowing there were fewer limitations on their means of travel. This attitude was further reinforced with the addition of public service buses between the boroughs.

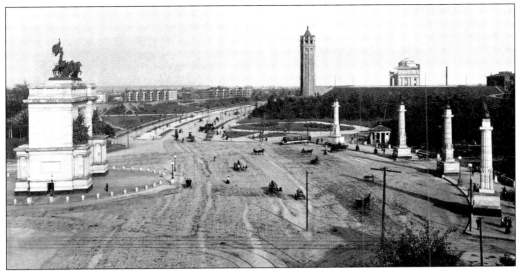

Eastern Parkway came to symbolize the Brooklyn West Indian community in the latter part of the 20th century, mainly as the route for its carnival. The parkway was hailed as one of America's grandest boulevards at its completion in 1874. However, when this picture was taken some years earlier, it was just a grand horse-and-buggy road. To the right are the columns at the entrance to Prospect Park. In the background is the Brooklyn Museum, punctuated by a water tower, which has since been torn down.

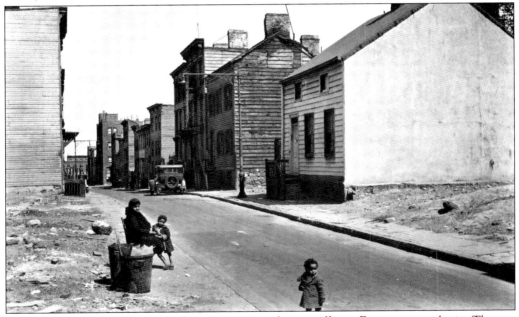

The earlier Irish immigrants had a reputation as being ruffians. Eminent sociologist Thomas Sowell described the males as the type who would "bite off your ear or nose . . . in a street fight." Their neighborhoods were the most dreaded by outsiders. By 1936, when this photograph of Talman Street in downtown Brooklyn was taken, however, they were just too happy to relinquish the neighborhood to the native and West Indian blacks. A housing project eventually rose on the site.

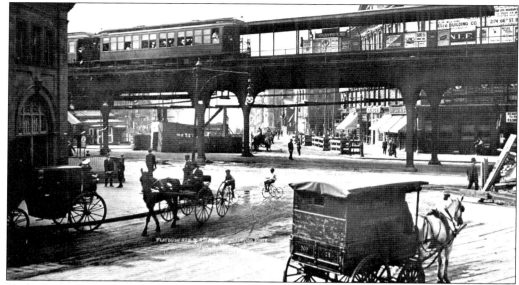

Flatbush Avenue is pictured at the Fourth Avenue juncture. The overhead train rail seen here turned south and proceeded down Fifth Avenue toward Bayridge. In 1912, the automobile had not yet made an impact on public transportation, and much commuting was still done by horse and buggy. Flatbush Avenue, at this time and place, intersected two black neighborhoods—one just off Fourth Avenue and the other at Myrtle Avenue just before the Manhattan Bridge. If you look closely, you can detect several blacks in the picture.

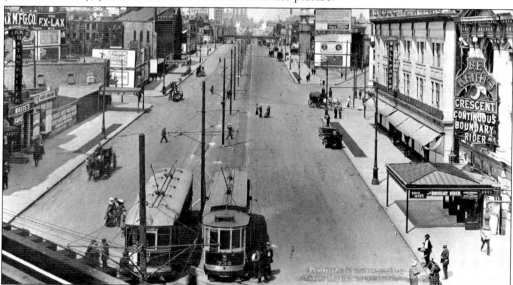

This 1914 photograph shows the strip that came to be known as the Flatbush Extension. Accordingly, the addition was undertaken to alleviate the congestion along Fulton Street that ran down to the Fulton Ferry Landing—the embarkation point to Manhattan. After the Manhattan Bridge was built, however, the original proposal was abandoned, as the extension led right into the bridge. In the background is the Myrtle Avenue el. The large building on the left would be torn down to make room for a bank. The areas flanking it at the distant end of the street were slums where many of the early black immigrants lived.

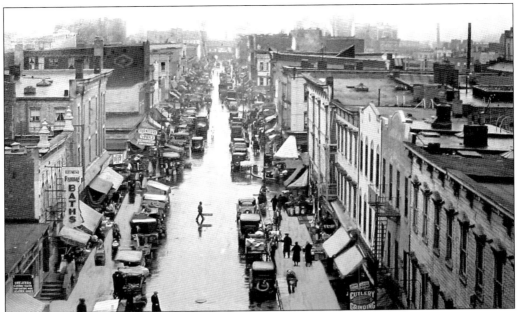

Brownville was built by eastern European Jews for eastern European Jews. The homes were smaller and plainer than elsewhere in the city. According to some historians, they were modeled on the *shtetl* of eastern Europe and were built more for shelter than for comfort. Taken in 1933, this photograph of commercial-laden Belmont Street shows one of the places where a young Shirley Chisholm often shopped with her mother.

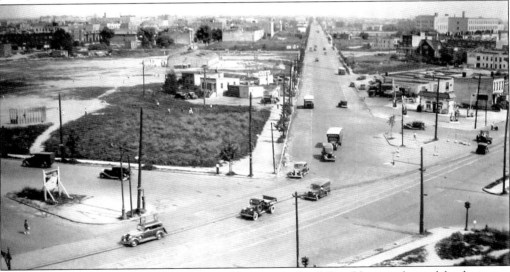

This 1912 photograph represents a veritable crossroads of Brooklyn, each road leading to a different ethnic neighborhood. Utica Avenue is intersected by Empire Boulevard in the lower left corner and East New York Avenue in the center, with Remsen Avenue originating in the middle. Some two decades later, the empty lots shown in the center were filled in with single-family homes, and the neighborhood took on a distinct Jewish flavor. Beginning in the 1970s, a West Indian population began moving into the neighborhood and now accounts for the majority of its residents.

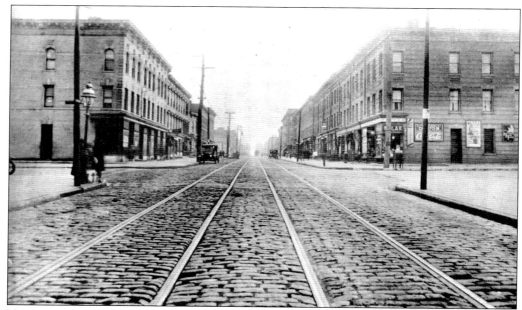

Utica Avenue in Stuyvesant town was one of those streets closely associated with New York City West Indians. A retail commercial strip, it runs through two central Brooklyn neighborhoods that have become largely black—Bedford-Stuyvesant and Crown Heights. In 1919, when this photograph was taken, however, few blacks lived south of Prospect Place, seen in the center of the picture. Their movement southward accelerated after World War II.

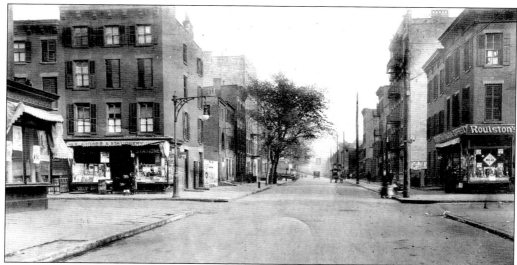

The downtown Wycoff Street neighborhood is shown as it looked in 1918. The photographer apparently wanted to avoid the block to the lower left of the picture. At that time, the block was a slum of mostly Irish and Polish people, with considerable numbers of Caribbean and American blacks. The blocks farther north were also fairly slumish. Both were torn down after the war and replaced with public housing projects.

Life for early-20th-century housewives was not always anticipatory routine. With automobile transportation still in its infancy, time was an important element of the day's function, and housewives had to manage their time in order to catch the pushcart peddlers on their daily rounds. Former congresswoman Shirley Chisholm, who partially grew up in Brownsville, remembers standing vigil for her mother at the window, hoping to catch the produce peddler on his rounds of the neighborhood.

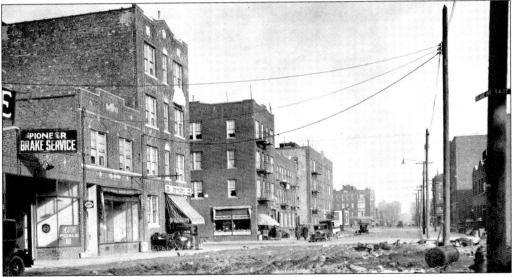

Blake Avenue at its Ralph Avenue intersection (from which this 1927 photograph was taken) was considered by some to be the boundary between Brownsville and Crowns Heights. Some of Brownsville's more successful eastern European Jews had purchased single- and double-family homes west of the elevated tracks of the Interborough Rapid Transit (IRT) line. In the 1960s, the Crown Heights side went through another transition, as most of the properties were taken over by West Indian blacks in what some termed "blockbusting."

19

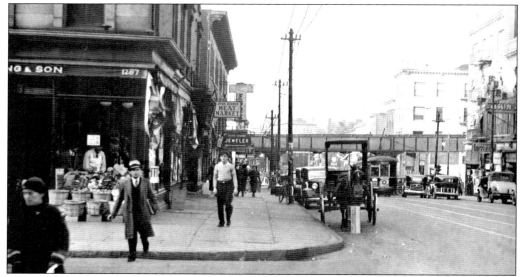

Nostrand Avenue is pictured in a 1932 view looking north from Pacific Street. In the background are the overhead tracks of the Long Island Railroad just before their descent underground; the station is just out of frame to the right. For many years during the Great Depression, black West Indian and American women would gather under the station tracks to vie for housecleaning jobs in the suburbs. One writer described the process as undignified: "They would be made to form a line and the agent would walk along it poking and inspecting them as if they were livestock."

Utica Avenue at Eastern Parkway was once a principal center of commerce in Crown Heights. The stop is accessed by both the express and local IRT trains and several bus lines. In the 1940s, when this photograph was taken, middle-class Jewish and Italian American shoppers would converge on Utica Avenue to shop at the retail outlets there. Much of that changed, however, after the 1977 power blackout in which there was a frenzy of looting of commercial businesses. Today, the residents are mostly West Indians, but the intersection continues to be one of the busiest junctures for black commuters.

Bainbridge Street off Utica Avenue was a nice working-class neighborhood "where many Irish and Italian families lived among some Jewish," according to Dr. Evan Gordon, seen in the center of the picture. Gordon remembered that he got along fine with the white neighborhood kids for the first few years after his Vincentian parents (reputed to be the first blacks on the block) bought a home two houses down from Malcolm X Boulevard (then Reid Avenue) in 1936. He also noted that "as more Blacks moved into the neighborhood the Whites were no longer as friendly."

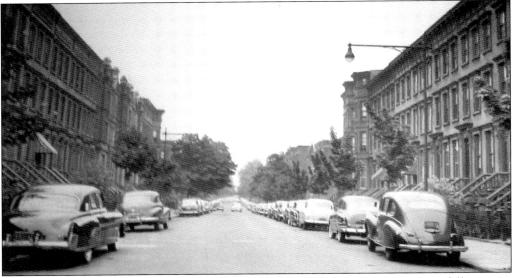

The postwar years were good ones for Brooklyn blacks. With industries running at full capacity and unemployment at its lowest levels, blacks were finally beginning to share in the American dream by being able to acquire the symbols of middle-class life. Jefferson Avenue in the late 1950s exhibited this. Here can be seen the neatly kept homes and shiny automobiles of those West Indians and American blacks who, prior to the war, were struggling desperately just to stay afloat.

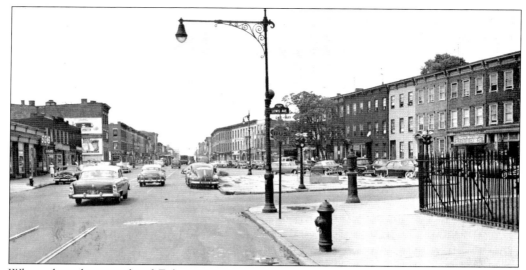

When this photograph of Fulton Street was taken in 1956, the neighborhood was almost entirely populated by black Americans and West Indians. To the right is the fence of the Robert Fulton Park East of Lewis Avenue, in which is located the Utica station of the Independent Rapid Transit (IND) subway line. To the far right is the defunct terminus of Chauncey Street, now a housing project. At the southern end of the park, Stuyvesant Street terminates. Up until the 1980s, the neighborhood was home to an assortment of black professionals. It was during this period that the renowned Brooklyn Boys High School relocated in a new building across from the park.

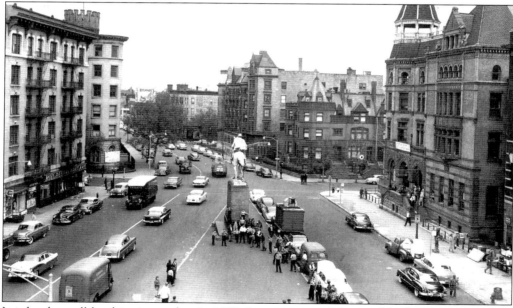

It is hard to tell by this picture, but in 1958 the transition of this neighborhood from white to black was already well on its way. The photograph shows Rogers Avenue as it converges on Bedford Avenue just before it crosses Dean Street. The impressive building at the right is the old Union League club, built in 1891. It later fell on hard times and became a training seminary for the Lubavitch Jews. In the 1990s, it was leased to the city to be used as an antipoverty facility.

Flatbush Avenue and its extension are pictured at rush hour. This photograph was taken in the mid-1960s, when the famous strip was still associated with Jewish commercial dominance. City buses have replaced the trolleys, and the spidery legs of the overhead rail have since disappeared. Not long after, the latest wave of Caribbean immigrants began arriving and rapidly transformed the district.

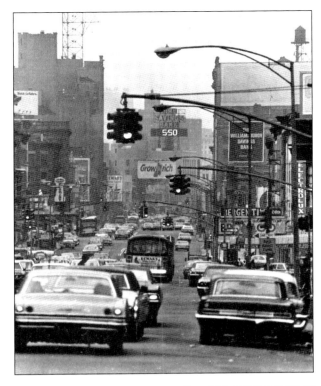

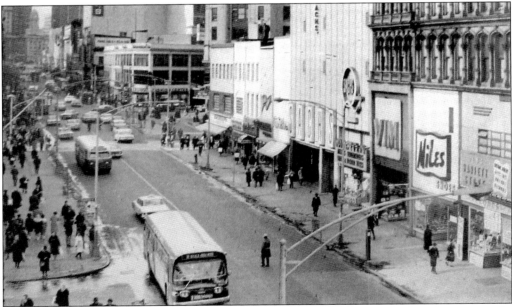

Fulton Street is shown in 1964. In this view, the transition from an upscale shopping center of a generation earlier to a shopping bazaar is already evident by the abundance of discount stores. Not long after, Martin's department store, a fashionable establishment for men's goods, closed its doors forever. Other stores that catered to a middle-class element also closed. The clientele base of the area today is largely American blacks and West Indians, many of whom arrived after 1965.

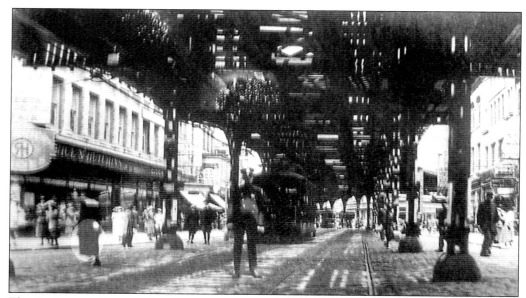

The Lexington Avenue el was convenient and useful to Harlem blacks who worked in the Bronx during the early years. That group included many of the new West Indian immigrants. Harlem commuters would catch the train at the 125th Street station and arrive in the Bronx just moments later at 149th Street. From there, they would either continue on by alternate rail or take one of the many route trolleys. In 1918, when this picture was taken, that would have been the normal transportation procedure.

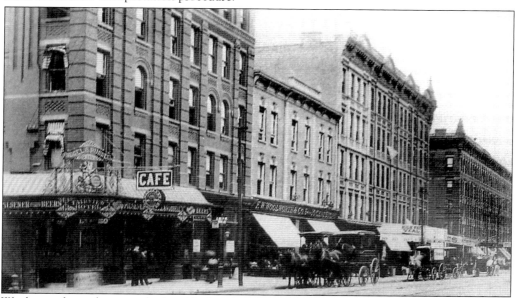

We know from the records that blacks were living in this section of the Bronx when this photograph was taken in 1907. These blacks were, in some instances, West Indian maids and porters who serviced the magnificent buildings of the wealthy on the Grand Concourse and Jerome Avenue. One of the oldest districts of the Bronx, Mott Haven was favored by blacks for two reasons—its proximity to Manhattan and the affordability of its old buildings as homes. Pictured here are the old tenement buildings, many of which are still standing.

No borough has borne a greater brunt of Robert Moses's misadventures than the Bronx. The New York master builder moved people and objects around with such reckless abandon that they may as well have been chess pawns. Here, he is tearing down a lower-middle-class neighborhood in the Bronx in order to built the Bronx Crosstown Expressway. The road divided what was one community into two communities, creating a division not only of structures but of spirits as well.

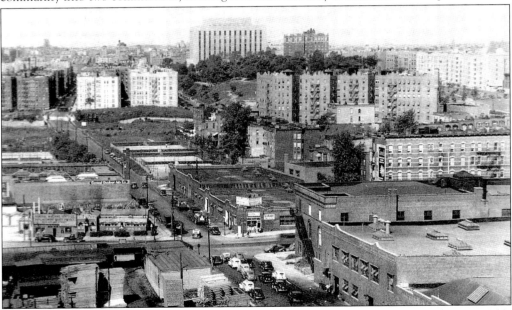

This section of the Bronx has changed very little since this photograph was taken in 1939. Blacks, as a rule, did not live here. They worked here, however, mostly in the big apartment buildings along the Grand Concourse, seen to the upper right, or in the myriad of small factories in the lower center. The big white structure in the distance is the Bronx county courthouse, where Caribbean American district attorney Robert Johnson now presides over his judicial charge—a far cry from his youth, when the only likelihood of him working there was in reverie.

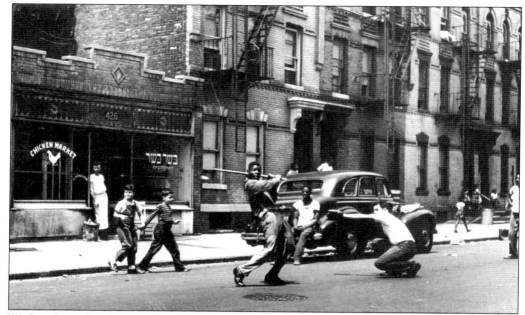

With urban development progressing at a rapid rate after the Great Depression, many empty spaces and sandlots were lost to homes. The streets became the playgrounds, and the immigrants' pastimes changed to American leisure. One of the most popular games among male youths was stickball. The sport was even more common in the black neighborhood of the city after the admission of Jackie Robinson to Major League baseball.

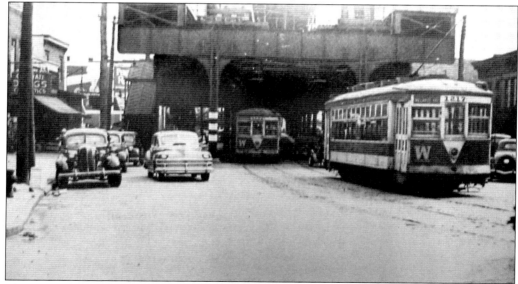

This IRT line begins its run in the Bronx at 149th Street and Grand Concourse and terminates at 241st Street on White Plains Road in the Wakefield district. It is the train, many claim, that was partially responsible for the large-scale movement of West Indians from the South Bronx to the north, which seriously got under way in the late 1960s. The chief incentive of this migration was, of course, affordable family homes. The West Indian stream that headed north did not stop at Baychester but continued right on through to Mount Vernon and Yonkers.

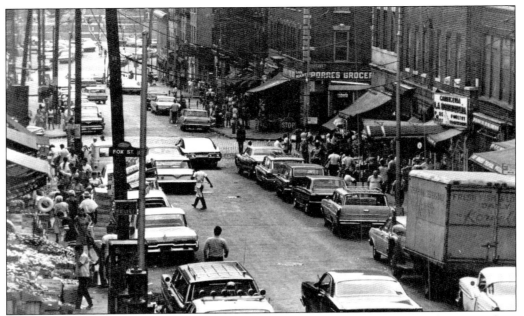

This 1960s photograph of Boston Road at the intersection of Fox Street shows a robust commercial center. By this time, however, the exodus of the pre–World War II Caribbeans out of the South Bronx had already begun. Most resettled in the North Bronx in the Wakefield-Baychester district, where single- and double-family homes had become available through new development and the departure of their former owners. Today, an impressive number of North Bronx residents are of Jamaican descent.

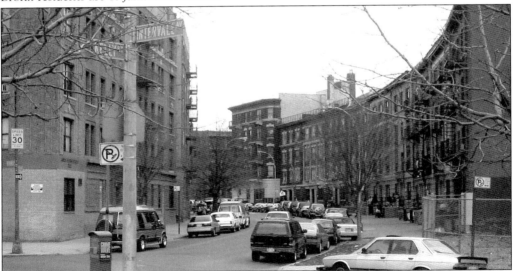

Banana Kelly (or what is left of it) is seen from Intervale Avenue. The street—the childhood playground of native son Colin Powell, who would go to become the military's principal general and U.S. secretary of state—was later amputated at the section between Intervale and Longwood Avenues and made into a neighborhood ballpark. Today, the accent heard on this field is mainly Hispanic, many of its users recent residents of the neighborhood nurturing Major League aspirations.

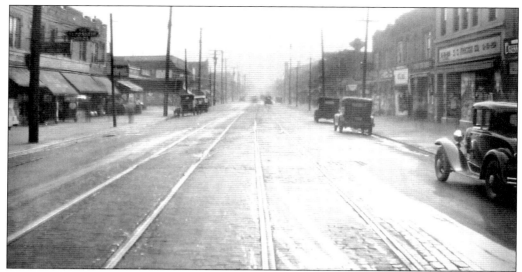

Liberty Avenue, running east from Leffert Avenue, is shown in this 1932 photograph. Before it gained importance as a rail route, it was just another dirt road that took buggy commuters from the community of Brownsville to those of South Jamaica. Clearly visible are the trolley tracks of the Long Island Electric Railroad, which began service in 1896 and ran along Liberty Avenue from Grant Street in Brooklyn to 160th Street in Jamaica. One year after this picture was taken, trolley service was discontinued and replaced by commuter buses of the Jamaica bus line, which is now one of the principal transportation of the community's West Indian residents.

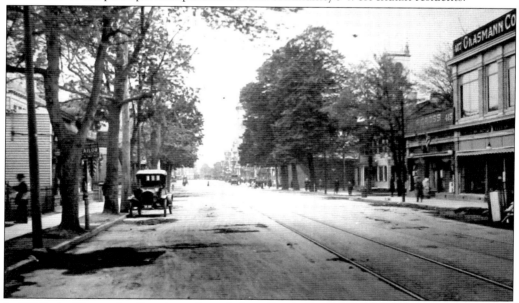

In 1917, the Turner family migrated north from South Carolina and bought a home in South Jamaica. That same year, this picture of the town's most famous strip was taken. At the time, the street was known as Fulton, and the corner from which the picture was taken was called Clinton. Several years later, both were changed to Jamaica Avenue and 165th Street, respectively. The street name changes were undertaken to facilitate the increase in human and vehicular traffic and had no effect on the shopping habits of the Turners.

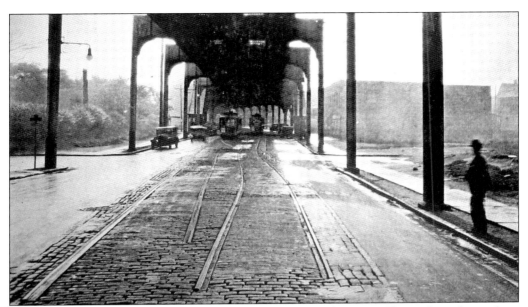

Liberty Avenue is shown in a view looking east from 100th Street. The spider columns bear the elevated tracks of the IND subway train, which terminates at Lefferts Avenue in Richmond Hill. A juncture at the Rockaway station continues to the right toward Far Rockaway. The rail, completed in 1915, was joined to the Brooklyn section during the Great Depression and was instrumental in the mass migration of blacks out of Manhattan and Brooklyn to Queens.

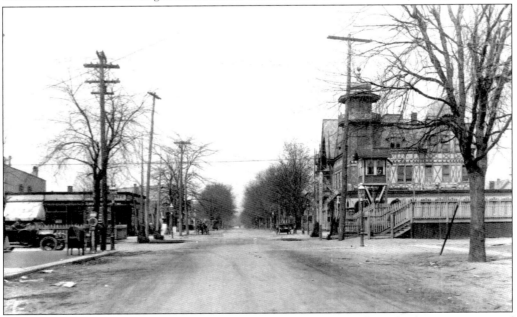

Lefferts Avenue, running north from Atlantic Avenue, slices through the community of Richmond Hill at this point, crossing the main thoroughfares of Hillside and Jamaica Avenues. At the time this photograph was taken in 1913, the population was largely Irish and German, with a sprinkling of Jewish and Italian. By the 1970s, however, Caribbeans of East Indian descent began settling in the area and today constitute a plurality of its ethnic population.

In 1927, Linden Boulevard was still a dirt road and Cambria Heights was little more than a developer's dream. However, with the construction of rows of affordable family homes (of the type seen in the distance) and the laying of vehicular roads from South Jamaica's commercial center, all that changed and the town grew rapidly. By the 1960s, many of the older West Indian and southern blacks of Brooklyn and the Bronx began buying homes south of the avenue. They were followed in turn by the post-1965 immigrant West Indians.

Before Count Basie, Lena Horne, Fats Waller, and other notable blacks turned St. Albans, Queens, into a haven of the famous and wealthy, the community had already established itself as a prosperous suburban town. St. Albans was established as a community in 1900, but it was 20 years before a rash of housing developments turned it into one of the most sought-after towns in Queens. At the height of the civil rights struggle, middle-class blacks began moving across Francis Lewis Boulevard (shown here at 131st Street) to Cambria Heights in order to avoid poor blacks, who they believed were causing depreciation in their property values.

Some sociologists have attributed the eventual transition of Cambria Heights from an almost completely white community to a predominantly black area to an initial miscalculation of developers in overbuilding. Pictured in 1940, these quaint single-family homes on 114th Avenue at 227th Street had been on the market for a considerable time before finding buyers, a few of whom were black. In the early stages of the community's development, blacks mostly resided on 111th Avenue off Sutphin Boulevard.

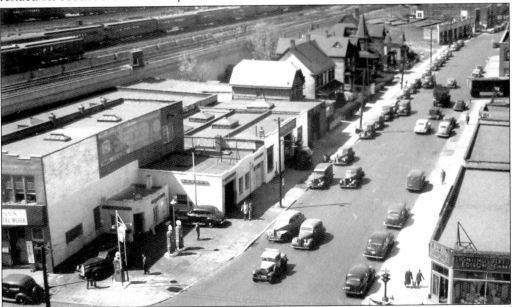

Archer Avenue, intersected by 150th Street in Jamaica, Queens, is shown on a summer's day during the 1930s. The tracks of the Long Island Railroad can be seen to the left. To the upper right is the train station where so many West Indian house workers disembarked. Their employers would come by in their cars to pick them up, as the bus system to the outer areas was not yet fully operational. It is reasonable to assume that some of the cars parked along the curb are there for that purpose.

In this 1958 photograph, the trolleys and streetcars have long disappeared from Jamaica Avenue, but the overhead train track is still a visible presence. The view looks west from Parson Boulevard and shows a fairly deserted section of the strip that only a few years earlier was hailed as one of the great commercial centers of the city. In 1967, the city tore down the overhead and replaced it with an underground subway in its continuing effort to revitalize the community.

Liberty Avenue is pictured in a view looking west from 124th Street. The eastern portion of the avenue runs right through the Richmond Hill district to Jamaica Township, where many of the structures have remained virtually unchanged for the last 50 years. What has changed, however, is the ethnic configuration, with West Indians of East Indian descent replacing the Irish and Italians as the principal population. The storefront sign to the left pretty much tells the story.

Two

Civil Rights

Black activism in New York City can be traced as far back as the American Civil War, with the issue of emancipation then being the focus. It was not until the beginning of the 20th century, however, that demonstration for inclusion into the American system on the basis of equality began taking place. These protests at first took the form of passionate speeches enunciated by soapbox orators on street corners. Their mission, they would claim, was to educate and inform the black masses, most of whom had missed out on any formal education under the yoke of slavery or in its oppressive aftermath. The West Indian immigrants usually filled this education gap. Having been subjected to a less restrictive form of slavery and being emancipated a couple of decades earlier than their American counterparts, they were better prepared, both literately and temperamentally, to take on the challenge of civil rights—and they did. However, it would be assuming too much to conclude that the endeavors of these activists were motivated purely out of fraternal obligation or conviction to principles. Through individual pursuits or family connections, many had distinguished themselves in their native lands as members of the privileged class and were more than a bit surprised and disappointed to discover that all their special privileges were abrogated by the policies and practices of segregation once they set foot in the United States. Their militancy, therefore, may well have been more out of frustration than an expression of righteousness.

Curiously, most of these West Indian activists gravitated to the Socialist and Communist ideologies, joining such organizations that advocated and enunciated the doctrine of social equality and human rights. Given the political climate of the period—in which capitalism was still in a bitter struggle with alternative ideologies—and the overriding attitude of the privileged public toward the disenfranchised masses, such response was only natural. However, in the fog of the political warfare of the times, it would never be recognized as such. Activists were relegated to the fringe and reviled—even by some of those for whose cause they fought—as troublemakers.

The first of these street activists to gain any semblance of public recognition was Hubert Harrison, a native of the Danish West Indian island of St. Croix, which would later be annexed by the United States as a commonwealth state. Harrison would set himself up on a stepladder and preach to Harlem's commuters. Eventually, he would extend his base of operation to include the Wall Street district of Manhattan and downtown Brooklyn. In a way, his advocacy set the stage for the great civil rights struggle that was to follow, and he would be copied in style and substance by the succeeding generation of civil rights advocates.

Although a contemporary of Harrison, the black nationalist Marcus Garvey borrowed liberally from Harrison while employing his own brand of populism. Garvey's advocacy of self-reliance was matched not only by words but action as well and was so relevant that it resonated beyond the confines of black Harlem to the entire nation. Other prominent Caribbean activists of the period included Jamaican journalists W.A. Domingo, Joyce Campbell, and Rev. Ethelred Brown; writers Claude McKay and J.A. Rogers; Barbadian evangelical orator Richard Moore; Virgin Islanders Frank Crosswaith and Cyril Briggs; and Guyanese political strategist McDonald Holder. By the 1950s, a new generation of activists had established themselves, but they differed from the prior in one very important way—they were mostly American born, among them Malcolm X and Louis Farrahkan.

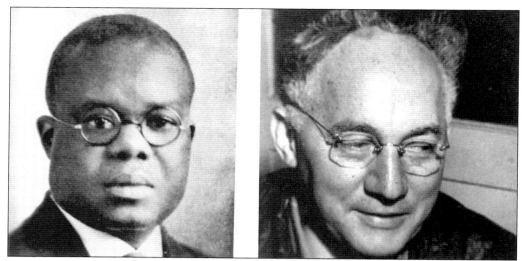

Fewer people have contributed more to the enlightenment and education of the city's black masses than Virgin Islander Hubert Harrison and Kittian Cyril Briggs. Yet, the two could not have been more opposite. Described as "ink black" with unattractive features, Harrison was eloquent and dynamic with a power of oratory that never failed to leave his audience in awe. Briggs, on the other hand, was so fair that he was frequently mistaken for white—a perception he sincerely resented. Moreover, he suffered from a speech impairment that was overlooked only by his wide knowledge of the subject on which he spoke.

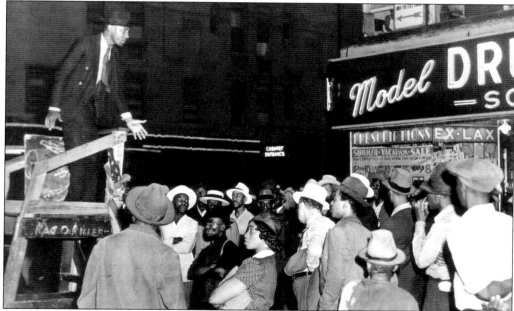

During the first quarter of the 20th century, the term *rabble-rouser* was used pejoratively to describe a certain kind of West Indian. These were the political activists who would take to the streets to inveigh against social condition for blacks. Their pulpit was sometimes an empty milk crate or, more commonly, a stepladder of the type shown in the picture. The latter method was developed by the Virgin Islander Hubert Harrison, considered in some circles to be the greatest of the street orators, Garvey notwithstanding.

Richard B. Moore (left) and W.A. Domingo are shown as they appeared in their prime. Barbadian Moore arrived in the United States in 1909 at the tender age of 16, hoping like most immigrants of the period to find meaningful employment and settle down to a life of tranquility. It was not to be, however, and he gravitated toward social activism. W.A. Domingo immigrated from Jamaica in 1910. A gifted journalist, he made his case for racial justice with his pen and became one of the staunchest advocates for a monolithic black community at a time when the idea was not so popular.

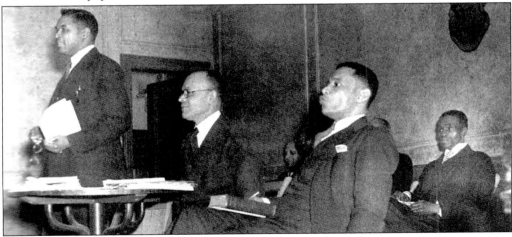

Three of the West Indies brightest are pictured here. From left to right, journalist W.A. Domingo, historian J.A. Roger, and social activist and lecturer Richard B. Moore debate each other in 1940. Although deeply involved in civil rights matter as it affected the American community, they were also dedicated Caribbean Nationalists who were seriously concerned about the fate of the region in light of Hilter's advances in Europe. Galvanized by the uncertain direction of World War II, they would launch the West Indies National Emergency Committee to represent the interest of the region.

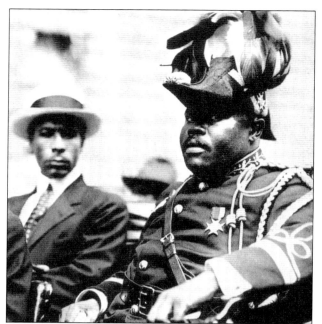

Marcus Mosiah Garvey, described by both his critics and admirers as bombastic and arrogant, was among the most brilliant organizers of his time. Believing himself to be chosen by destiny to be the ultimate leader of the world's black masses, Garvey began his international crusade at a quite young age, traveling first to England and then to Central America to preach his doctrine of African Nationalism. It was in the United States that he found his fame. He immigrated to the country in 1916 and eventually established a following of hundreds of thousands. In 1923, however, he was indicted and convicted by the federal government for extortion and was subsequently deported.

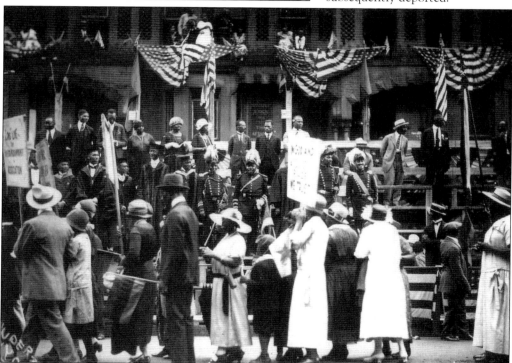

Marcus Garvey loved a parade. Some of his critics claimed he feasted on adulation as a leech gluts on blood; it was necessary to sustain his obsessive drive, which transformed him from a virtual unknown into one of the country's most celebrated figures in half a dozen years. In this view, he is reviewing a march-by of some of his admirers and is obviously enjoying it. He is the stocky one in the center, with the single row of coat buttons and the sash.

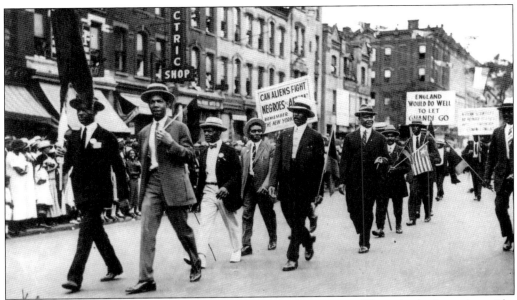

Garvey's parades were not entirely all about pomp and pageantry. They also had a serious side, as is evident in this picture. The paraders are carrying placards calling on England to get out of India, which it had colonized, and for immigrant West Indians to join with the black Americans in their struggle for equal rights. The unity of black West Indians and Americans was not an automatic thing at the time, and Garvey had to tread carefully when dealing with the issue.

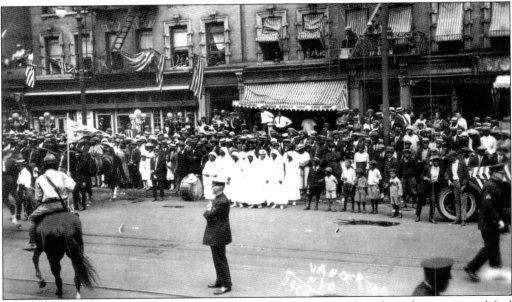

Marcus Garvey, more than anything else, was a showman, and nothing better exemplified this than his lavish parades. There were male and female militia, black cross nurses, mounted cavalry, foreign Legionnaires, and even an air corps. Blacks who had never quite been taken into the bosom of the American society reveled in these grand flights of fantasy, and many became passionate supporters of Garvey and his movement of black liberation.

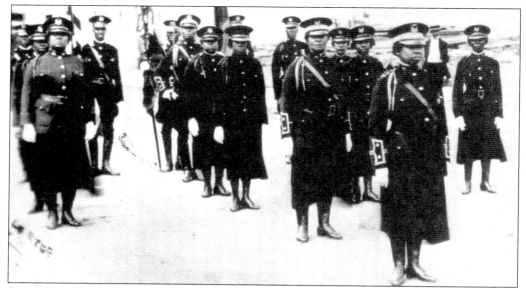

Some critics have maintained that Marcus Garvey was ahead of his time. At least in one instance this may be true—he was promoting the idea of a female militia at a time when it almost seemed ridiculous. Up until World War I, women in the U.S. military were almost nonexistent, and whatever few there were served only in the nurse corps. Garvey put women in military uniform and paraded them around as a militia of his United Negro Improvement Association (UNIA). Shown in the picture is his female brigade.

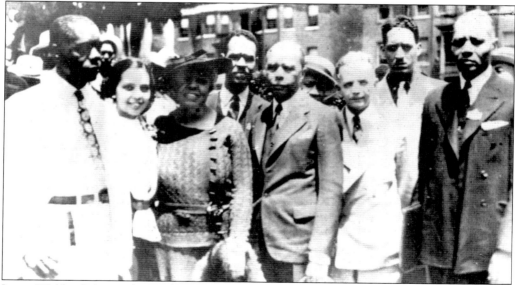

James Weldon Johnson (center) was one of the early fighters for civil rights, although he never gained the notoriety that some of his more vocal contemporaries did. Born in Jacksonville, Florida, to Bahamian parents, he would choose the vehicle of the establishment from which to wage his struggle. In 1906, Johnson joined the U.S. diplomatic corps and spent the next six years serving as consul in Venezuela and Nicaragua, after which he spent two decades directing the NAACP. Following in his footsteps, many Caribbean immigrants and their progenies would join the organization, some allegedly for the prestige it brought them.

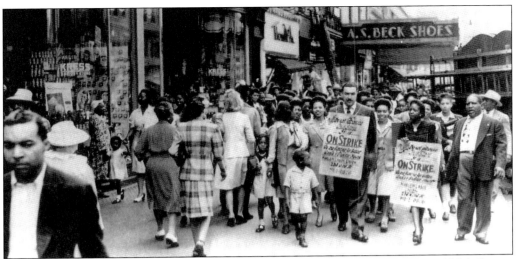

During the early part of the 20th century, the center of the black universe was on 135th Street, but all of the important commercial establishments were located on 125th Street. Blacks could shop at the many stores that lined the strip but not work at them—that was until a young Baptist minister named Adam Clayton Powell Jr. began leading street demonstrations demanding of their owners that blacks be hired. The owners eventually capitulated and began hiring blacks.

Generally credited with being the most astute black political strategist of Brooklyn, Guyanese Wesley McDonald Holder has been instrumental in the success of many of the most notable of Brooklyn's politicians, including Mayor Ed Koch, Congressman Ed Towns, and Assemblywoman Mary Pinkett. In 1968, Holder engineered the election of Shirley Chisholm to the U.S. Congress. He thereafter served as her chief of staff until her retirement 12 years later. His death in 1994 was mourned not only by the politicians but also by the entire black community of Brooklyn.

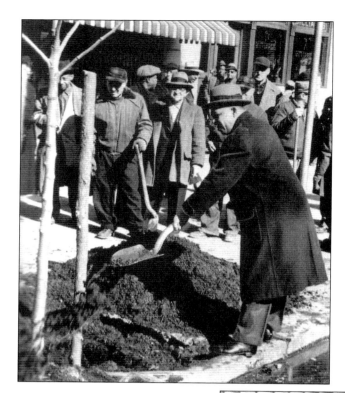

Some have said that he was brilliant; others have maintained he was reckless. Both descriptions might have been true of Hulan Jack, the St. Lucia native who was elected in 1940, at age 36, to represent the district of Harlem in the state assembly. Thirteen years later, he became New York City's first black municipal leader when he was elected borough president of Manhattan. In 1960, however, in a public scandal that included charges of corruption, he was forced from office.

Born to a West Indian family in New Haven, Connecticut, federal Judge Constance Baker Motley came to the attention of a white businessman who was so impressed by her superb intellect that he arranged for a scholarship for her. Later, as a lawyer for the NAACP Legal Defense and Education Fund, she worked closely with Supreme Court Judge Thurgood Marshall on the high-profile suit Brown vs. the Board of Education. This case resulted in the desegregation of the public schools throughout the nation in 1954. Moving on to politics, she was elected to the New York Senate and later to the Manhattan borough presidency.

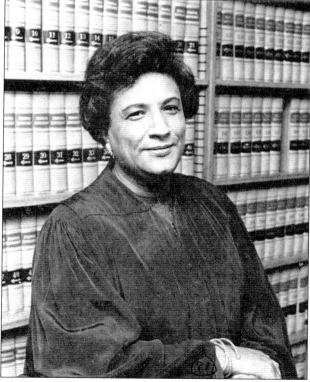

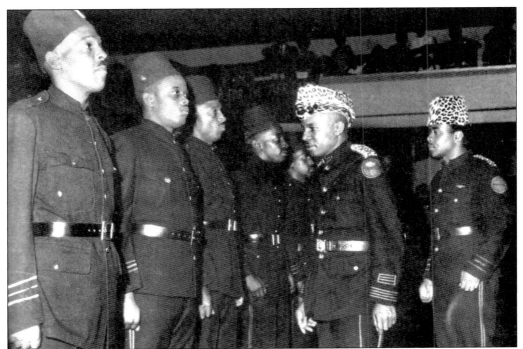

With the deportation of Marcus Garvey from the United States in 1928, the Universal Negro Improvement Association was left leaderless. One of those vying to succeed him was his youth director, Carlos Cook. Born in the Dominican Republic of parents who hailed from the tiny island of St. Martin, Cook immigrated to the United States at the age of 16. He later joined the United Negro Improvement Association. With the departure of Garvey and the virtual dissolution of the organization, he formed his own—the African National Pioneer Movement. In this photograph, Cook is inspecting a squadron of his militia.

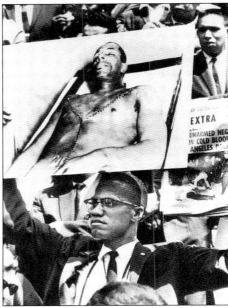

In 1962, Malcolm X was still a devout follower of Hon. Eliah Muhammed and a fiery advocate for the curtailment of rampant police abuse. As leader of New York City's Black Muslim, his rallies were as much occasions for enlightenment as they were protests against the system. Here, he is seen demonstrating at a Los Angeles rally called to protest the death of Ronald T. Stokes, who was unarmed at the time he was killed by the police during a skirmish. The autopsy stitches on the dead man's body are clearly visible in the picture held aloft by Malcolm X.

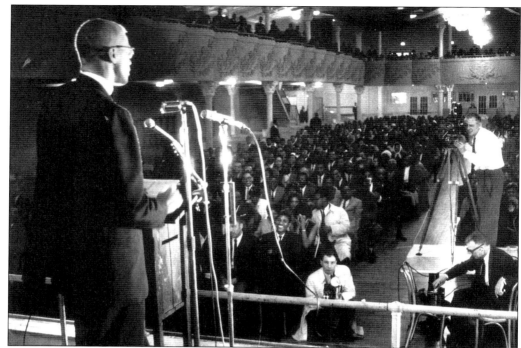

Malcolm X is shown lecturing at the Hotel Theresa. In its heyday, the Theresa was visited by many important figures. By the mid-20th century, however, it was in decline. In a last grasp at glory, it extended its hospitality to Cuban president Fidel Castro and the charismatic black leader Malcolm X, inviting them in as guests. Malcolm X, who often spoke there after his split with the Nation of Islam, is seen in 1964 addressing a gathering of his followers at the Theresa.

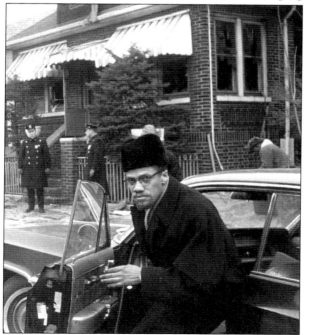

Malcolm X is shown arriving at his home, having just been notified by the police that it has been firebombed. By this time, he had broken with Hon. Elijah Muhmammed, leader of the Black Muslim, and was striking out on his own. Powerfully charismatic with a flair for oratory, his new movement was seen as threatening his old organization by cutting into its support base. This ignited the spark that ultimately consumed him.

Stokely Carmichael, the Trinidad transplant, had the brain to make it in almost any endeavor he chose. America, however, was not a color-blind society, and Carmichael knew his dark skin would limit his options. The Bronx High School of Science graduate therefore opted to change things and went off to black Howard University to become a civil rights activist. As president of the Student Non-Violent Coordinating Committee (SNCC), he would leave his mark as a champion of the civil rights struggle and leave it to history to debate over the correctness of his choice.

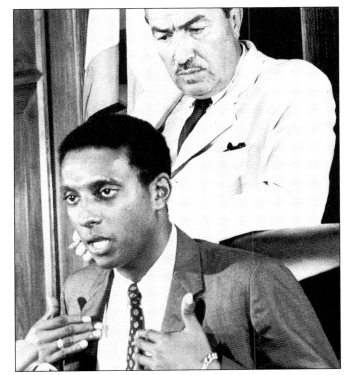

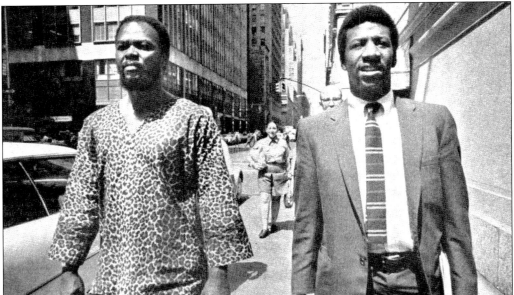

In the 1960s, Roy Innis was a young civil rights activist with a nationalist bent that some say was reminiscent of his compatriot predecessor, Hubert Harrison. A trained chemist, he would bring to the exercise of social activism a conservatism and preciseness to details that is most uncommon. After assuming the directorship of the Congress of Racial Equality (CORE), he grew progressively more distant from the liberal views he once espoused and was shunned by former colleagues. He is shown here (left) at an earlier time with an aide, Victor Solomon.

One of the angriest voices to come out of the 1960s belonged to black intellectual Leroi Jones, also known as Amiri Baraka. A child of the civil rights generation and the product of West Indian immigrants, he would turn his contempt upon the white establishment. He also heaped scorn on his parents' heritage, embracing instead the concept of Afrocentricism as his redeeming feature.

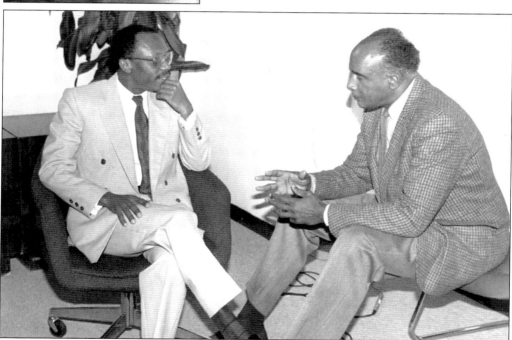

Following in the footsteps of his ancestral countrymen W.A. Domingo and J.A. Rogers, Caribbean American journalist Gil Nobles uses the medium of television to agitate on behalf of the disenfranchised blacks of the city. His weekly program *Tell It Like It Is*, one of the most popular public interest programs, is approaching its 30th anniversary of informing and educating New Yorkers on the subject of blacks. He is shown here having a preliminary confab with Haitian president Jean Bertrand Aristride, prior to going before the camera.

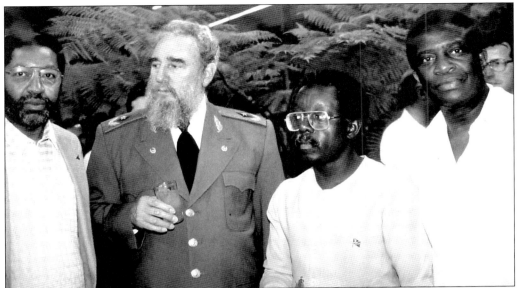

Elombe Brath and Fidel Castro are shown at their New York meeting in 1990 at a black liberation conference. One of Harlem's most enduring spokesman of black issues, Brath is both admired and respected by third-world leaders, many of whom eagerly seek his council. His attraction to political activism may be a natural outgrowth of a family tradition, many of whom had distinguished themselves as fighters for the downtrodden. A favorite uncle, West Indian nationalist Clennel Wickham, would become a historical figure for his effort in uplifting the Barbadian masses.

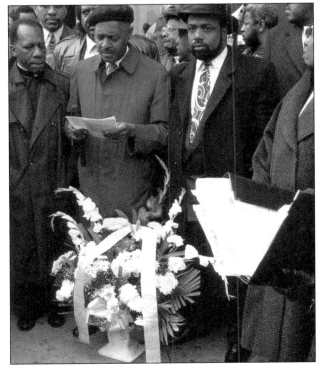

By the mid-1970s, the civil rights movement had peaked, and the focus had shifted away from sit-in and boycott demonstrations for integration to protests against police brutality. In New York City, the move was sparked by the unjustified shooting of several blacks residents over a period of time by white police officers. This led to an initiative of common cause between African Americans and Caribbean Americans. Here we see one of the leaders of the movement, Rev. Herbert Daughtry of the House of the Lord Pentecostal church, leading a prayer vigil at the scene of a police slaying.

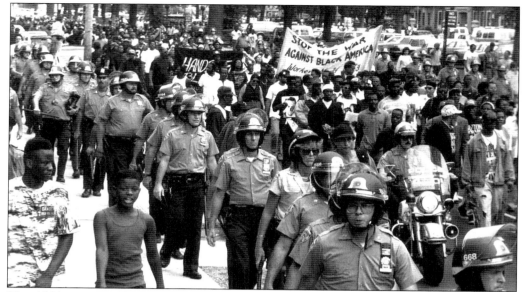

This 1991 scene on Eastern Parkway tells it all. A once quiet neighborhood of considerable opulence just three decades earlier, the community has now descended into a hotbed of racial tension, pitting blacks against Hasidic Jews. Shown in the picture is a street demonstration protesting the police handling of the death of a young Guyanese boy by a Hasidic driver. The march followed three days of rioting in which a Hasidic man was killed.

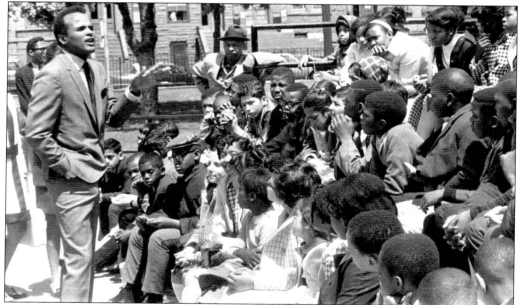

Harry Belafonte, moved by the indignities suffered by blacks at the hands of whites, became an ardent admirer and disciple of Rev. Martin Luther King Jr., often traveling with him throughout the South in his struggle for instituting racial equality. In 1963, Belafonte played a pivotal role in organizing King's civil rights march on Washington. He was tapped the same year by Pres. John F. Kennedy to be the cultural advisor to the Peace Corps. Always endeavoring to influence history, he is seen here speaking at a youth rally organized by the Restoration Corporation.

Three

PURSUITS

The problem that confronted the immigrant West Indian in the early 20th century was how to progress within the framework of a clearly color-conscious society without being rebellious. America was a nation founded on the principles of virtue that gave hope to even the most deprived, and indeed by the time the West Indians began arriving en force, there were already myriad examples of rags-to-riches successes. For a few, however, these were all members of the Caucasian race. This fact did not consciously deter the immigrants at first, who were just happy to be in a land where the terrain of opportunity seemed endless and who could not think of themselves being anything less than a full human being. So, with this conviction as the cornerstone of their disposition, most opted for a pursuit of applied knowledge, believing it was the correct path toward financial aggrandizement, which was the reason they had immigrated in the first place. Gradually, some began seeing things for what they really were—a collective denial of expression and opportunities for people of color. This prompted serious retrospection on the part of some who eventually arrived at the conclusion that the factor of race had so dichotomized the society that it would be necessary to bridge it psychologically before the laws on hand could be applied impartially to all. Moreover, they believed, the only way this could be brought about was through an expression of militant activism. Thus, it was this acknowledgment more than anything else that influenced the field of endeavors pursued by the early West Indian professional aspirants. Yet, there was clearly more to it.

That the areas of medicine and law should be the overwhelming choice of blacks opting for a professional career may suggest choices that were motivated less by the space for opportunity than impulse of egotism. There is little evidence of the times that shows black lawyers and doctors to have prospered in ways commensurate to those professions. Even those practicing within working-class black neighborhoods did not benefit greatly for it, as those residents with any financial means were more inclined to seek medical and legal assistance from white practitioners elsewhere, leaving only the dire poor, who usually found it difficult to pay. Dr. Harold Ellis, who practiced in Harlem during this period, recalled, "The Blacks who had money back then were the school teachers and garment workers, and they didn't believe in black doctors."

This behavior, according to some, was pervasive, and to a degree endemic of the black thought process, which suggested whites' supremacy over blacks in the professional skills. However, it was also a thought nurtured and instilled by whites. Another black doctor, Harold Ellis, remembered being told by a white doctor, "That's very good for a black doctor," as an applause for a suggestion he had rendered. A notable exception to this may have been the clergy. Black congregants, for the most part, preferred being pastored by a member cohort. Yet, even here, there was some deviation, with some middle-class West Indians clearly favoring white pastors.

In the less prestigious professions, the choices were more defined and practical. Teachers, social workers, medical technicians, accountants, secretaries, and others offered opportunities that were made available by the very necessity of the existing circumstances. Black service providers having a need for these skills felt it an obligation, and an expression of comfort, to hire members of their cohorts. In addition, those with the prerequisite skill would also find work in the public sector, in the various governmental service agencies.

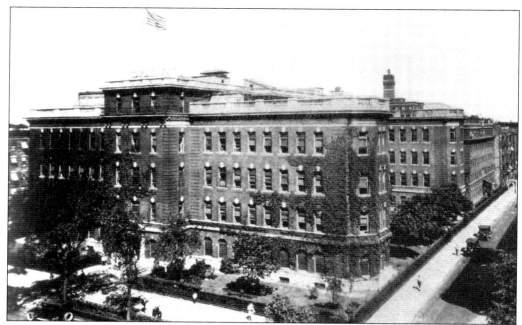

Harlem Hospital is pictured as it looked in 1920. Up until World War II, it was the only medical institution in Harlem that would accept blacks as patients. At about the same time this photograph was taken, a black doctor was hired as a staff physician for the first time, and not long after, black nurses were accepted. None of this would erase the hospital's reputation as a terrible institution in which to be treated. In 1933, West Indian doctor Conrad Vincent protested conditions at the hospital and enlisted the support of Rev. Adam Clayton Powell Jr. to raise the issue publicly.

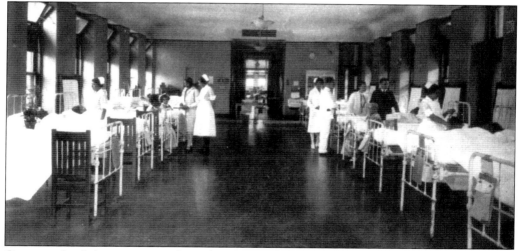

Open wards of this type were the only ones available to black patients in the city hospitals during the early part of the 20th century. This arrangement was quite often more harmful than helpful to the patient's health, in that it increased the chances of contagion through direct contact with each other at a time when there was no cure for a number of communicable diseases. For that reason, those who could afford it would eagerly check into one of the many sanitariums when the need for medical attention arose.

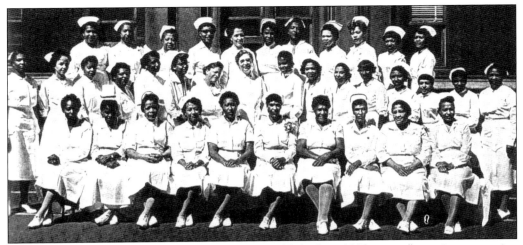

The Harlem Hospital School of Nursing was established in 1923 as an "experiment to give Negro girls the opportunity to train for professional nursing." The school, which was connected to the Harlem Hospital, was most welcome by many of the immigrant Caribbean women, who craved for employment that was more meaningful than cleaning homes and tending to babies of the wealthy. Many seized upon this opportunity to maintain or improve their social status.

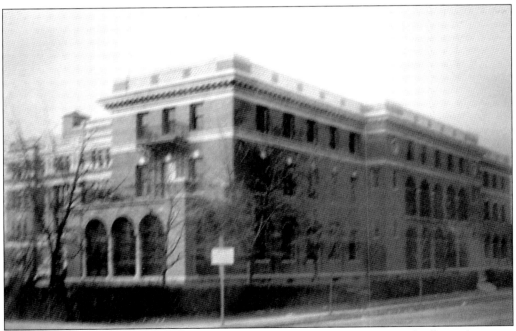

The N building of the Kings County Hospital, at the corner of Clarkson and Albany Avenues, was built in 1912 and, for a time, was used for most of the hospital functions. However, during the mayoral tenure of Jimmy Walker, funds were appropriated for the construction of a larger hospital to meet the medical needs of the growing population of the borough. In 1937, an entire new hospital complex was built, stretching from Utica Avenue east to New York Avenue west, thus making it the largest in the country at the time. The institution was eventually incorporated into the city's Health and Hospital Corporation.

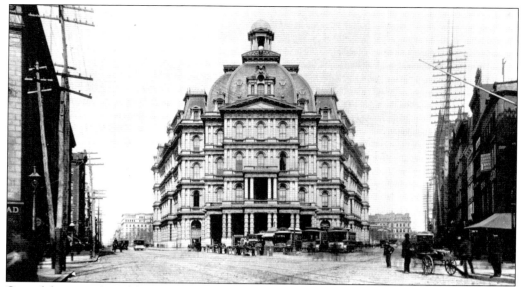

One of the most desirable jobs a black could have during the early 20th century was as a postal clerk or mail carrier. Yet, it was often necessary to have some kind of political connection to land one of these positions. In the beginning, many would be placed in a postal office within a black neighborhood. Gradually, they began finding positions at the main branch, which until 1939 was located in downtown Manhattan south of city hall. This office, shown in the picture, was eventually demolished and replaced by one in mid-Manhattan.

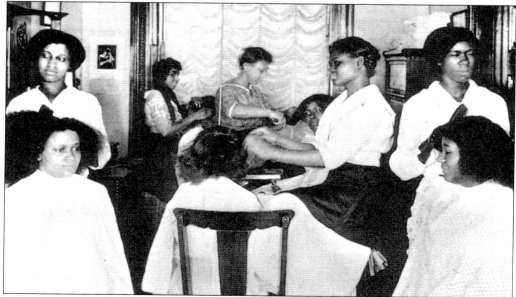

During the first quarter of the 20th century, there were few career opportunities available to young black women, regardless of how educated they were. Many, in fact, resigned themselves at very early ages to the life of a domestic. Others, however, sought alternatives in the limited endeavors that were opened to them. One such area was that of coiffure, which Madam C.J. Walker, with her new methods and flashy lifestyle, would greatly glamorize. In the pre-Walker times, as it is for these patrons, it was just another tedious day at the hairdresser.

This artist's depiction shows what it was to be a groundhog, the name given to the laborer working underground. In the building of the various tunnels, West Indians usually constituted a greater number of the black work force. There was, however, nothing unusual about this; that type of work was considered very dangerous, and the American-born worker felt no compulsion to put himself at risk. It was somewhat different with the immigrants, who were determined to make the best of the opportunity.

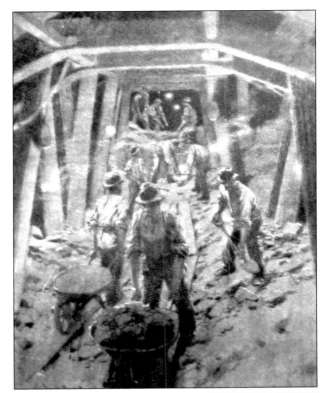

The West Indians who did comparatively well during the early years were those who came to the United States via Panama, fresh from working on the canal. Many had experience in heavy construction and knowledge of operating American equipment. This favored them over the locals for employment in the construction of the subways and other major capital projects. Moreover, many arrived armed with letters of recommendation from their former employer.

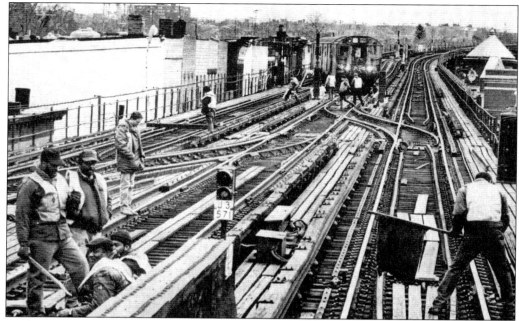

No longer relegated to the lowest levels of employment, blacks by the 1950s were represented in substantial quantities in a number of technical skilled jobs of the trades. Many Caribbean blacks would have found jobs with the transit authority at all levels—even at some management positions. In time, one of them rose to be head of the transit union. Seen in this 1970s photograph is an integrated work crew repairing tracks somewhere in the Bronx.

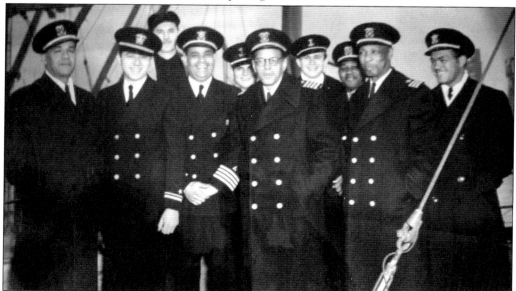

The war was good for the career of Capt. Hugh Mulzac and the ambitions of many aspiring black naval officers. Here, the captain (center, right) is seen with his crew of the SS *Booker T. Washington* during World War II. Mulzac participated in several convoy runs across the Atlantic at the height of the war and successfully evaded the dreaded Nazi submarines on each occasion. Not unexpectedly, his contribution to his adopted country was appreciated.

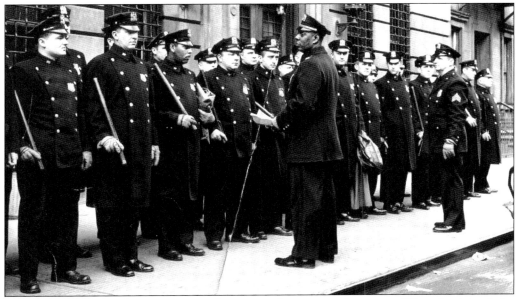

Lloyd George Sealy, shown reviewing his troops, has come a long way. When he joined the New York Police Department in 1942, the most he could hope for was making it to sergeant. Yet, by the time he retired in 1969, he had attained the rank of deputy inspector and collected along the way two university degrees and a law degree—something his Barbadian janitor father would never have thought possible. Born in Harlem but reared in Brooklyn, Sealy also went on to a distinguished career as an academician, rising to full professor of police science at the John Jay College.

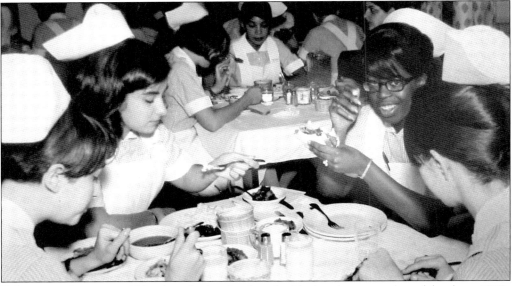

Tokenism is how it would be described today, but the blacks who were selected for these 1940s nurse-training classes at the Kings County Hospital school saw it as a great stride forward. The young lady with the glasses in this photograph went on to distinguish herself in the profession and held several supervisory positions during her career. As she most likely would have put it, she was "paving the way for others."

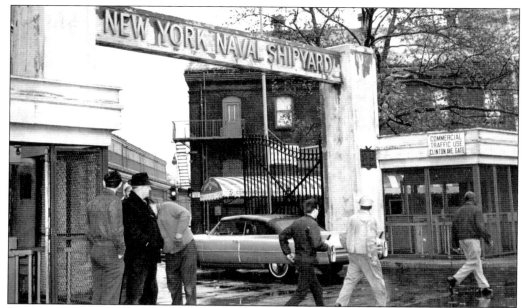

In 1964, when this photograph of the Brooklyn Navy Yard was taken, those workers on their way to their jobs may have sensed that the fate of the yard—with no more great wars to justify its existence—was already sealed. One year later, it was closed as a federal base, bringing to a close 165 years of naval shipbuilding. The yard, however, would be remembered fondly by Barbadian Estelle Jones and many of her cohorts, who had been able to find their first decent-paying jobs there making uniforms for the sailors and soldiers of World War I.

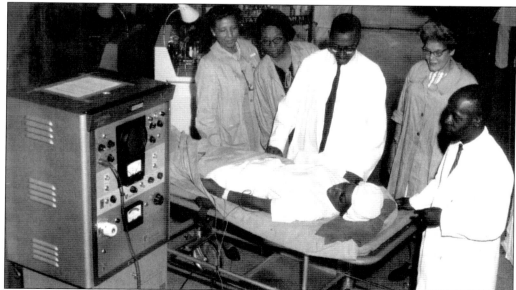

All the medical personnel seen in this 1960 photograph of a Harlem Hospital emergency unit are black. However, there were times not long removed when the only black person seen in any such photograph would have been a patient. As late as 1919, the institution had no black doctors on staff, and it was only through the exertion of community pressure, in the form of street demonstrations, that changes were implemented to allow for the hiring of black professionals.

"Be a doctor!" or "Be a lawyer!" were paternal admonitions not exclusive to Jewish children but were common to West Indians as well. The problem, however, was that there were insufficient vacancies at the universities to accommodate all those aspiring to these professions in pre–World War II America, and blacks bore the brunt of this scarcity. It took the civil rights struggle to right the imbalance and make scenes such as this biomedical campus at City University commonplace.

Dr. Muriel Petioni is shown as she recently appeared on the cover of the prestigious Columbia University medical journal. Something of an icon in the Harlem community, this retired physician still carries on a rigorous routine that combines exercise with community activities. Unlike so many of her contemporaries who have chosen to disconnect, the good doctor has never lost touch with her Caribbean heritage and has been the inspiration and source of many scholastic works on the subject. She is delighted that a larger-than-life image of her father is exhibited at the Ellis Island museum.

The military—prior to the Korean War, when it was integrated by Pres. Harry Truman—was not a good career choice for blacks. Moreover, during peacetime, it was quite exclusive. In times of war, however, sentiments of patriotism, coupled with the fact it provided a paycheck, made it an attractive options for blacks. By the beginning of World War II, Pres. Franklin D. Roosevelt had so convinced blacks they had a place in the America that even the immigrants were scrambling to join. This photograph, taken in 1943, shows a black company on bivouac.

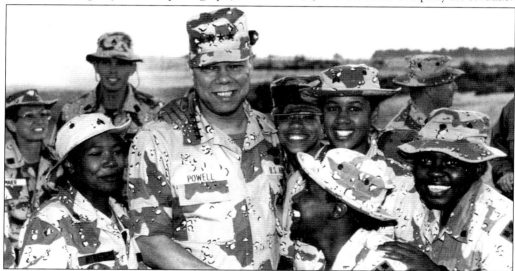

Gen. Colin Powell is pictured on tour. Just as popular as he is with the establishment elites so is he with the rank and file of the military. One of the things Powell quickly learned on his way up the stairway of power is that everyone is entitled to respect regardless of what place they occupy in the greater scheme of things. He also learned never to use race as a tool of favoritism and to judge everyone on the basis of his or her worth to the task—a lesson he got from his Jamaican father. These principles have served him well, as is apparent from the expressions of admiration that are being showered on him by the warriors of Desert Storm.

One of the truisms of New York is that any place there is a government housing project, you can rest assure the site on which it stands was previously a slum. This is also true of the Seaview housing complex in Canarsie, the area that was once the homestead of many turn-of-the-century immigrant Caribbeans and migrant blacks from the South. In the 1950s—when its most famous resident, Al Roker, resided there—it was certainly not a ghetto. To the future television personalty, it "epitomized the melting flavor of Brooklyn [with] the variety of nationalities who lived there all bonded by their lower middle-class status."

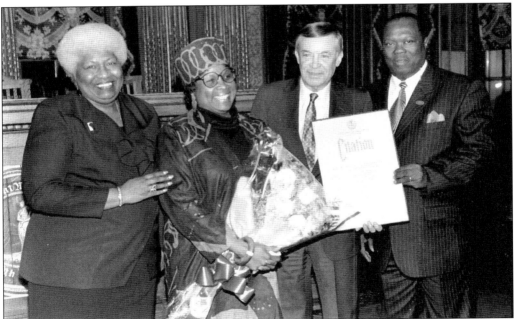

A gifted organizer who founded the Caribbean-American Chamber of Commerce, Roy Hastick is cited by the Brooklyn borough president, Howard Golden, for his work. The organization, which specializes in connecting budding Caribbean entrepreneurs to the leaders of large corporations, has been instrumental in getting a number of minority-owned businesses started in the community while augmenting the employment base. Also shown in the photograph are Jeanette Gadson, deputy borough president, and Prof. Edna Hastick.

Clifford Alexander, the son of a Jamaican father, made history by becoming the first black to be named secretary of the U.S. Army, a position he gained under the presidency of Jimmy Carter. Born to privilege (his father was a bank manager, and his mother was president of the League of Women Voters), he attended Fieldson Preparatory School in New York and earned a law degree from Yale University. In a distinguished public career, he served in the administration of three democratic presidents.

At a reception for the dedication of the Bed-Tower wing of the Kings County Hospital, Mayor Rudolph Giuliani heaped praise upon the director, Jean Leon, whom he noted had been able to run the hospital in the black ever since assuming its directorship. A native of Trinidad, Leon worked for many years in hospital administration before taking over the reins of Kings County in 1994. Here she is shown (center) with her staff in a recent photograph.

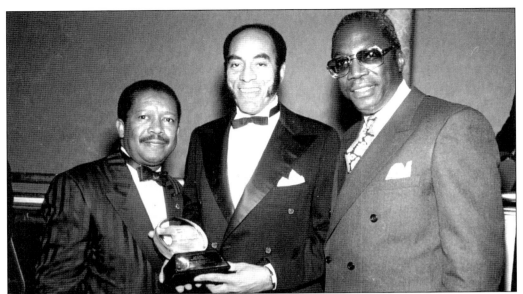

At a time when black businesses were being established at a rapid pace and failing at an equally alarming rate, Earl Graves (center) became one of a few who beat the odds by successfully launching the business magazine *Black Enterprise*. Born in Brooklyn to Barbadian parents during the turbulent period of the Great Depression, Graves went on to earn a bachelor of science degree from Morgan State College before joining the staff of Sen. Robert Kennedy. However, his venture into the public sector was a short one, and he quickly moved on to establishing himself as a premier publisher.

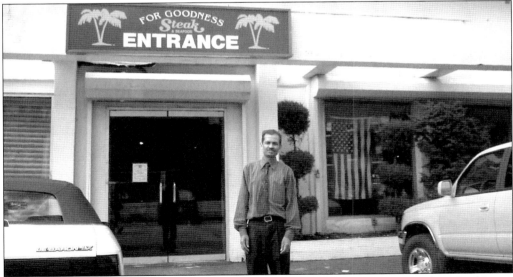

Certainly more industrious than their African-descent compatriots, the East Indian Caribbeans have gravitated more to the commercial side of pursuits than the personal professional endeavors. Although they have concentrated their efforts in the Richmond Hill district of Queens, their businesses (usually of the retail type) are also found throughout Brooklyn's West Indian neighborhoods. Here we see manager Alvin Singh standing before the highly successful restaurant of his cohort, David Singh.

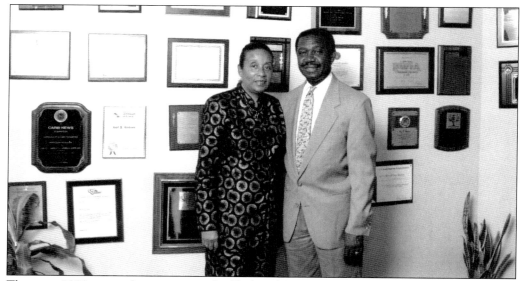

The year 1982 was a fortuitous one for Karl and Faye Rodney and for the New York City Caribbean community. Dispelling all odds and predictions of failure, the couple successfully launched the weekly newspaper *Carib News*. The paper, which serves the Anglophone Caribbean population of New York City, has become one of the community's principal sources of news, both domestic and foreign. In 1983, the paper got a big break when it became the feed to the mainstream press on matters relating to Grenada during the invasion of that country by the United States.

Actress Cicily Tyson first came to public attention as George C. Scott's dedicated secretary in the television series *Eastside, Westside*. She later moved to the big screen, appearing in a number of roles with a social theme. Born to immigrant parents who hailed from the tiny Caribbean island of St. Kitts Tyson, she has never forgotten her roots and frequently participates in fundraising activities to assist the poor and advance the quality of life in the land of her parents.

Four

HOUSING

Shelter to the black West Indian male, even during the period of bondage, was always seen as being equally cultural as fundamental. The West Indian male in his native environment almost never proposed marriage until he had first acquired a home for himself and his future wife. The prospective wife invariably accepted a proposal unless she was dissatisfied with the housing arrangement or the earning potential of her suitor. Couples who could not afford their own home usually lived together without a license, a practice more common at the lower social strata and viewed with a measure of condescending toleration by the highbrow. So the drive of the West Indian immigrant to have his own home—so irritant to many American blacks—had its basis more in ideology than in frivolity.

To the immigrants, however, the circumstance of living space presented an unanticipated problem because it was never as easily available in the big, industrial cities of the United States as it was in the rural, peasant-laden towns of the West Indies, from which most of them came. Homes were not as accessible, and home building was invariably the enterprise of a corporation with the means to handle the prohibitive governmental regulations and exorbitant expenditures. There were, to be sure, other impediments, which were mostly of a socioeconomic nature. Nor would the government's entry into the housing development significantly ease their burden because of selective regulations favoring citizens.

When West Indians began arriving in the United States en masse as freed individuals c. 1900, slavery was just a few decades behind them. Predominantly of black ancestry, they faced the same kind of prejudices and prohibitions as the native blacks. Although they were slightly better prepared for social integration than their American counterparts were, it nevertheless mattered at the employment marketplace. They were denied comparable pay to whites and were thus unable to readily purchase their own homes. The alternative then was a slow and arduous process of thrift, encouraged through a personalized rotating saving system that went by a variety of names—partnerbox, susu, bolita, and so on. This process ultimately led to the desired purchase, usually of a vintage home in some stage of disrepair and certainly not in the best of neighborhoods.

As conditions gradually improved, those blacks with better preparation were able to secure better homes in middle-class neighborhoods in the city. Invariably, these neighborhoods were thereafter abandoned by their white residents, thereby consigning them to the disreputable ranks and incurring the dreaded redlining—a banking device used to penalize resident homeowners of a particular district by making it difficult for them to secure home-improvement loans. The consequence was inevitable blight, the neighborhood degenerating into a slum—a term that came into popular usage during the Great Depression. Other neighborhoods, where housing was usually of the tenement and apartment type, usually followed a different path to the same conclusion, as the landlords—limited in their ability to extract a profitable rent and overburdened by taxes—would simply walk away from their properties, leaving them to the ravages of the elements and the vengeance of poverty. Eventually, they would be razed to make room for urban renewal. This pace of desertion, destruction, and rebuilding was heightened after World War II with the establishment of the housing authority and the abundance of federally subsidized transportation projects that made commuting easier to the suburbs. With substantive changes in the social milieu, brought about by the civil rights movement, newer immigrants increasingly found it easier to land better paying jobs and were more inclined to purchase homes in the suburbs than rent apartments in tenements or housing projects in the inner city.

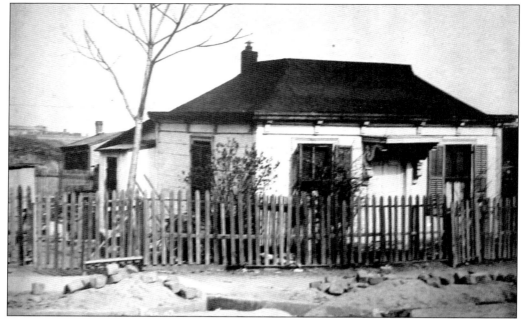

When this 1912 photograph was taken of the southwest corner of Franklin Avenue and Eastern Parkway, only the western portion of the community had been fully developed. It was three decades before most of the empty spaces east were filled in by apartment buildings and family homes. By the 1960s, when blacks began crossing over in large numbers to the neighborhood south of Eastern Parkway, many of these Mediterranean-type farmhouses in the area were long gone.

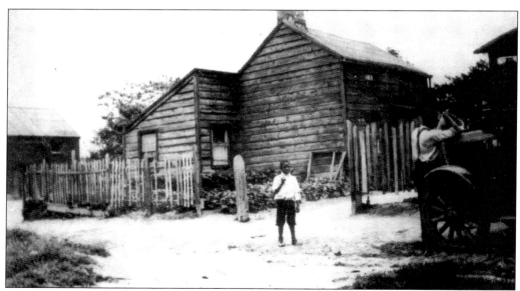

The area around Rockaway Parkway and Seaview Avenue, where this 1922 picture was taken, was then known as Carnasie Meadows. During the first quarter of the 20th century, it was home to many poor ethnic Italians and Irish. A sizable number of Caribbeans also lived there, mostly Bahamians, ship jumpers, and former stevedores from Barbados and Jamaica. In 1955, the city razed much of the slums and erected the Bay View public housing.

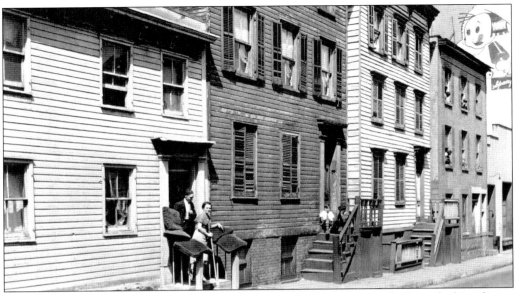

During the early part of the 20th century, it was not uncommon to see blacks and whites living side by side or in the same building. This, however, was true only of the poorer neighborhoods, such as Talman Street in downtown Brooklyn in the Fort Greene district, shown in this 1936 photograph. If you look closely, you will detect the little black boy sitting next to the white on the stoop and the black woman hanging from the second-floor window of the house at the far right. The area was heavily populated by immigrant West Indians during this time.

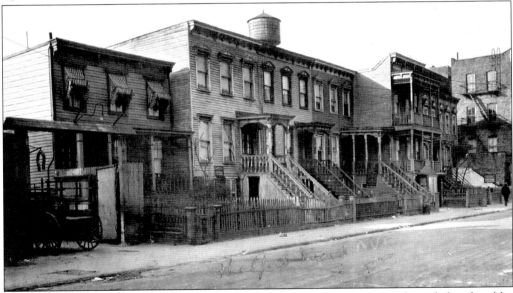

In the first quarter of the 20th century, many of these old wooden structures abounded in the older sections of Brooklyn. Brownsville seemed to have a disproportionate portion. Many of the earlier West Indian immigrants favored them to brick, in that they were more familiar with wooden structures. In addition, they considered them economically easier to maintain. Abandoned by their white owners, the neighborhood descended into desolation only to be revived by the Nehemiah Housing scheme of family dwellings sponsored by the Koch mayoral administration.

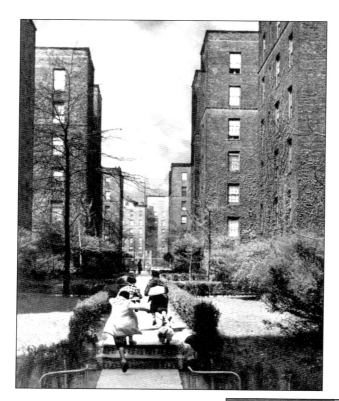

The Harlem River House of West 153th Street was built partly to ease the housing crisis that fermented the 1935 race riot. Although benefiting many of the newer migrants recently up from the South, it did little for the older Caribbean residents of the community who were unable to be accommodated because of stringent admission policies that penalized non-citizens. Nevertheless, it did ease the Harlem housing crisis for a time.

The Harlem housewife shown in this 1940s photograph may not have realized it then, but her lot was so much more superior to her antecedents of just two decades earlier and scores ahead of her West Indian counterparts in their island homes. Here, she has an indoor icebox, an oven, and a sink, in addition to a slew of cooking utensils. By this time, blacks were beginning to live the American dream, and discontent was beginning to shift from the material to the fundamental.

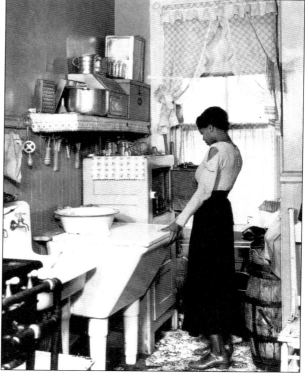

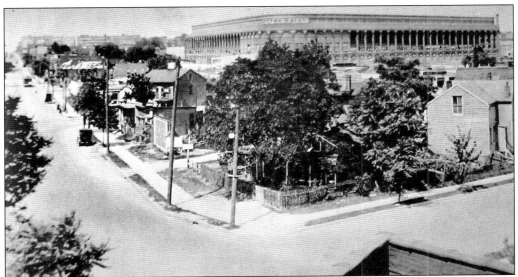

When Charlie Ebbetts built his magnificent sports stadium (seen in background) in the swampy wasteland of Brooklyn's "pig town" in 1913, little did he suspect he was also establishing a community. Soon after, the empty spaces around the stadium were filled up with middle-income family homes. When the stadium's occupant, the Brooklyn Dodgers, departed for the West Coast some years later, so did the original homeowners. Readily put on the market, these homes were quickly gobbled up by many of the blacks from Bedford-Stuyvesant.

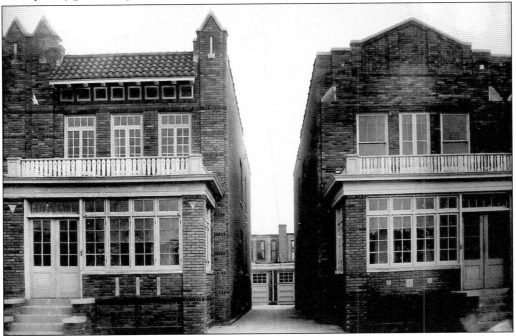

The Brooklyn neighborhood of Sullivan Street and Rogers Avenue was a swampy, mosquito-ridden patch of land referred to as "pig town" before Charlie Ebbetts built the Dodgers baseball stadium on it. Soon after, developers moved in and converted it into a habitable community with homes such as those shown here.

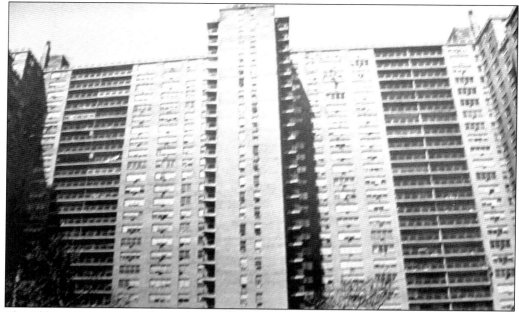

The Ebbetts housing complex now stands on the site of the defunct Ebbetts Field, home of the old Brooklyn Dodgers. The arena was demolished in 1960 and was replaced seven years later by the structure seen in this photograph. The building, situated in a heavily concentrated Caribbean sector of the borough, has been derisively described by some of its harshest critics as an oversize rookery. Many of its Caribbean tenants stay just long enough until they can afford to buy a home.

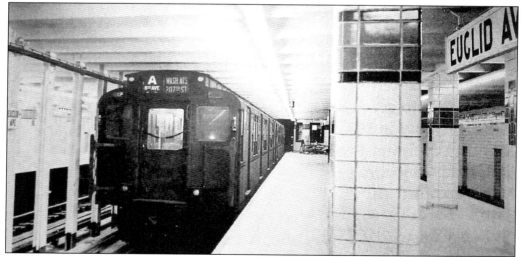

This is the A train, which has been credited with instigating the mass migration of West Indians out of Harlem to Brooklyn and indirectly to Queens in the mid-20th century. In the effort to jump-start the moribund economy of the Great Depression, Franklin D. Roosevelt approved Work Projects Administration funds to construct an extension of the IND subway from Manhattan to Brooklyn. The link released Harlem's black population from their geographic constraint by facilitating access to the outer boroughs. Within a few years of its construction, tens of thousands of blacks used it to flee Harlem.

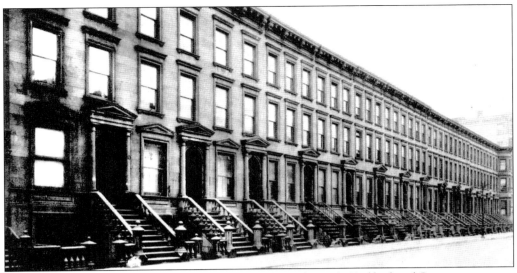

Rows of older brownstones were pervasive throughout the early Bedford and Stuyvesant towns of Brooklyn. This particular model, built in the latter 19th century, was not the earliest and was considered an opportunity by the black house shopper if available. The complaint many West Indians had with row houses, however, was that they took too much of a communal effort to keep up the property value. Moreover, many felt that they were never entirely their homes.

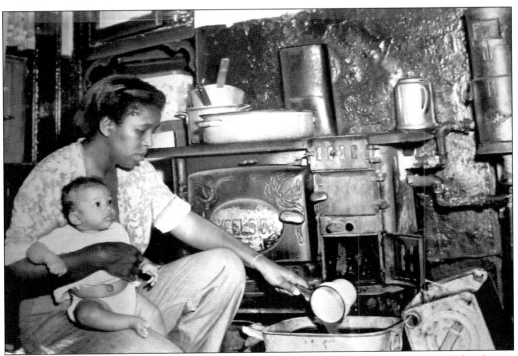

In 1952, the city administration of Mayor William O'Dwyer, acting on a campaign pledge, began investigating housing conditions in the black slums of Brownsville (where many immigrants lived) and discovered that things were worse off than had been imagined. Invariably, for tenants like this Brownsville mother, the only source of heat during the winter was the kitchen stove.

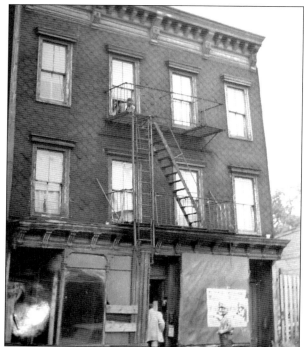

During the post–World War I migration of blacks to Brooklyn, many were forced to settle in the older parts of the borough. Most of the homes then available to them were of the older vintage, some having been built a century earlier, and were in dire disrepair, all but abandoned by their owners. The homes shown in this 1950 photograph on Lexington Avenue is indicative of the slumish conditions in which many of the poor were forced to live during this time.

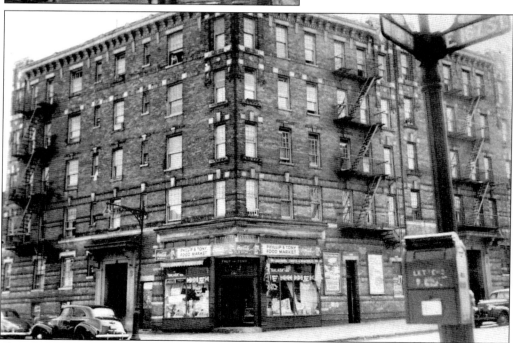

The Bronx in the 1940s and 1950s was a mixture of the old and the new. Unlike Manhattan and Brooklyn, large-scaled development of the borough did not begin until the start of the 20th century, when it was connected to the other boroughs by subway. The older apartment buildings, such as this one, were turned into tenements and were the type of residences available to the new Hispanic and black migrants to the borough.

The buildings along the southern tip of Stuyvesant Avenue in Brooklyn were once home to Brooklyn's most distinguished and wealthiest citizens. Some of the homes on this block were designed to the owners' specifications. Many years later, they came to symbolize the best of Brooklyn's black society, where the most successful professionals resided. The author remembers the area in 1960 as a place he would pass on his way to catch the subway train to work, where he would dream of someday living in such elegant homes.

Brownstones of this vintage and model in the upscale section of Fort Greene were very desirable and very expensive. These are of the Romanesque types and among the last of the models to be built. In the early 20th century, they were located only several blocks from the black population center of the borough, but it was many years before blacks were able to purchase them as homes. By the 1970s, many in the black population had joined the professional ranks with incomes that enabled them to afford more expensive homes.

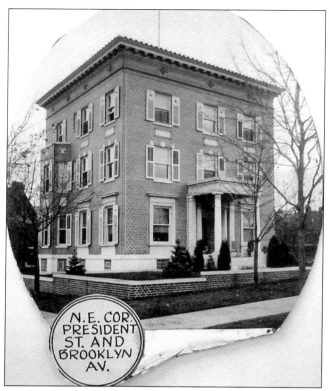

Elegant homes like the one shown in this 1919 photograph once formed the celebrated Doctor's Row, on President Street in Crown Heights. Beginning in the early 1960s, American and West Indian blacks from Bedford-Stuyvesant began crossing over Eastern Parkway into Crown Heights. Today, some of these homes are owned by black professionals and businesspeople. The building shown here was once owned by a well-known black activist doctor from Panama, who has since passed away.

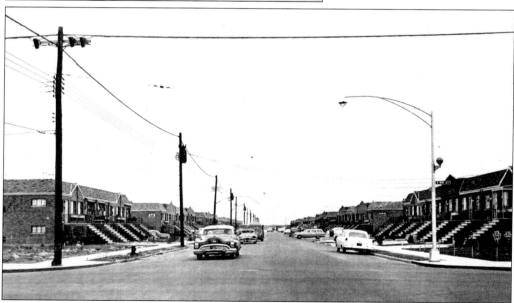

Up until the mid-20th century, the area around Rockaway Boulevard and Seaview Avenue in Canarsie was a barren patch with a few bungalow-type buildings. This, however, changed in the 1950s with the construction of Seaview Village, a collection of two-family homes. Initially a white neighborhood of mostly Jews and Italians, it was transformed to a black area in the 1980s with large settlement of Haitians and Anglophone West Indians of the post-1965 grouping.

The Amsterdam housing project is located between West 60th Street and 64th Street on 11th Avenue directly opposite Lincoln Center for the Performing Arts. Some 100 years ago, it was the black neighborhood of San Juan Hill, comprising American and Caribbean blacks in some of the worse living conditions to be found anywhere in the city. By the 1950s, the city, anticipating the gentrification of the neighborhood, commissioned the construction of the Amsterdam development with the primary intention of providing decent accommodations for the poor Irish who had been left behind. The Irish, however, advanced to the middle class, leaving the housing almost entirely to poor blacks and Hispanics.

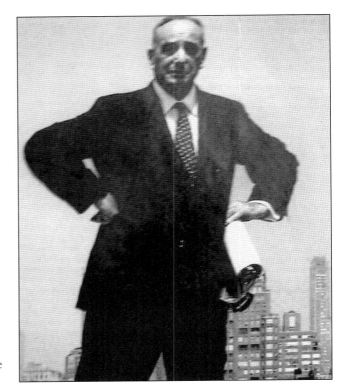

It has been said no single person had a greater impact upon the lives of the residents of New York City than Robert Moses. His ideas were often derived through machinations rather than by creative deliberations. Some of his detractors have claimed that he loved asphalt and concrete more than he did people. He destroyed the homes and the habitats of the poor (which included many immigrants) with impunity in order to build roads and capital showpieces that served principally the interests of the privileged class. In so doing, he changed the demographics of the city in incalculable ways.

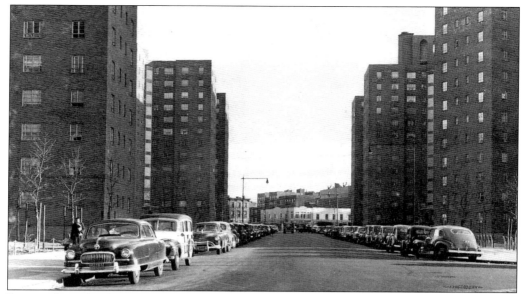

Just another of Robert Moses's concrete legacies, the Lester Patterson houses tower over their surroundings. The complex was built in 1952 in the Mott Haven section of the Bronx, but not before scores of apartment buildings and family homes had been razed to make room for it. At the time, it was heralded as a new epoch in family living for city dwellers. Barely two decades later, it was be termed an eyesore and criticized for being an incubator of crime. Many of the West Indians who lost their homes in the trade-off moved on to the North Bronx.

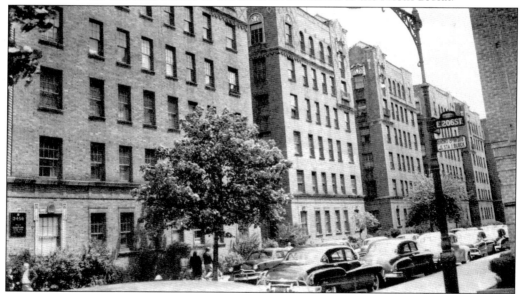

One critic remarked that the whole of the Bronx "appears to have been built by a single architect whose creative vision was stuck in neutral." Indeed, the borough is blanketed with apartment buildings of the type shown here, with their structural appearance differing only in nuances. The West Indians were never enamored of apartment buildings. In their postwar movement northward, they used them only as temporary shelters until more permanent ones could be obtained in family homes.

The decade following World War I witnessed the most spectacular growth in the Queens Village housing development. In the streets crossing Jamaica Avenue, hundreds of family homes of the type shown here were constructed. These developments were undertaken with the specific aim of luring middle-class families away from the inner city of New York—but not necessarily blacks, who would come years later. That the development succeeded at all was due in part to the Long Island Railroad locating stations along the route and the network of highways that was built, linking the community to the city.

This magnificent home at Hollis Park was once the residence of a former Queens borough president. Built in 1909, it was equipped with all of the amenities and trappings of opulence, including maid's quarters. In 1977, with the neighborhood undergoing a transition from white to black, it was purchased by a Caribbean businessman, Norris Archibald, shown posing on the back porch with his family. To most immigrant Caribbeans, owning a home is the fulfillment of the American dream.

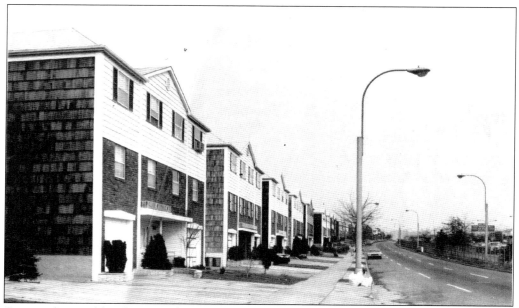

Country homes like the type shown in this 1974 photograph and found throughout South Jamaica were the kind favored by the post-1965 Caribbean immigrants, particularly the Haitians. Generally less educated and mostly of working-class or peasant stock, they continued the Caribbean tradition of homeownership but tended to be somewhat more cautious when purchasing homes, usually selecting from those that offered sufficient space to accommodate boarders in the event they ran into financial setbacks. This option would at least provide some means of meeting the mortgage.

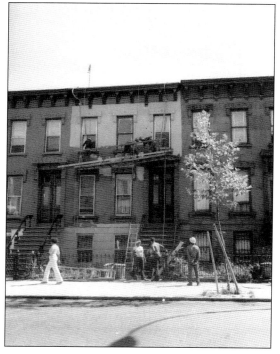

By the 1960s, some of the very housing jewels that had made Bedford-Stuyvesant so attractive were beginning to fade and crumble. The brownstones, which had been so prized by the early West Indians homeowners, were in varying states of disrepair, many of their earlier owners having moved on to the more affluent suburbs. In its effort to revive the community, the Bedford-Stuyvesant Restoration Corporation undertook to preserve the more salvable buildings. Here we see one of its repair teams at work on a damaged building.

Five

EDUCATION

Among the many dislikes the native blacks harbored of the earlier West Indian immigrants was their perceived pretentiousness, usually manifested in their reaction and response for immigrating, which was allegedly to secure an education in order to go back home. Although inconceivable to the Americans, this was not entirely untrue, as most would have undertaken the migratory sojourn with some sort of educational pursuit in mind, whether it was primary or of some lesser priority. Education, as it was understood, was deemed a necessity by the immigrants. However, there were surely other reasons for obtaining an education than the practical purpose of financial secureness, and that had something to do with perception—how the individual was seen and regarded by compatriots.

In West Indian society then, being principally class structured, a proper education was not only necessary for instilling knowledge but also for vesting the recipient with the essential accouterments of cultural elitism. A person did not necessarily qualify for high society if he did not come from a "good family," attend the right schools, or attain the proper credentials. Nor was the accumulation of great wealth an automatic pass to highbrow status, in that the two circumstances were not necessarily mutually consistent. To support this contention are the numerous stories told by survivors of that earlier period of wealthy Harlemites—some black West Indians with stupendous wealth—who were never allowed to join the same lodge and clubs of other West Indians of far less financial means, primarily on the basis that their wealth had been obtained through questionable dealings.

In their class-oriented society, education was therefore looked upon as the ultimate bridge to social prominence, which in a strange way was more important to the ambitious West Indian than money. It was the only vehicle that allowed one to move up freely from the lowest station to the highest, unencumbered. Yet, the avenues for securing a proper education in the European colonial societies of the West Indies were extremely limited, with only the tiniest of access available to those who lacked the proper connections. This was certainly not the case in the United States, where qualitative education could be reasonably obtained by anyone with the desire and ability. One had only to demonstrate a passion for diligence and perseverance to be successful.

To the earlier (mostly British) immigrants, education meant strict adherence to the European paradigms—those that they were accustomed to in their native lands. English citizenship was thought of as something special. For this reason, many parents withheld sending their children to the "inferior" city public schools and opted for one of the private immigrant elementary schools—some with denominational connections—that were a ubiquitous presence in the West Indian neighborhoods. One exception was the Catholic schools, where members of that faith felt an obligation to conform with the church doctrine, regardless of what doubts they may have harbored for the American educational standard. At the high school level, however, there was not much of an alternative, as space and access were drastically reduced. Many parents faced with this choice opted instead to send their children back to the West Indies to continue their education. However, for those who could not afford this undertaking (or were unwilling), choosing a reputable public school was the next best thing.

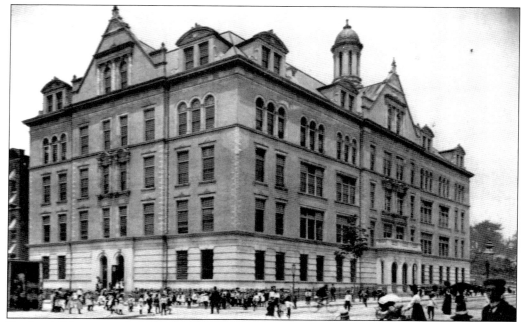

By the 1930s, most of the Harlem West Indians had shown a preference for the West Side and could be found in concentrated numbers along the strip between Eighth and St. Nicholas Avenues north of 116th Street. Up until it was decommissioned and turned into an apartment building, Public School No. 157 (shown in this 1899 photograph), on St. Nicholas Avenue and 126th Street, served the neighborhood as its elementary school. Even then, with a primarily black student body, one of its former students remembers there were no black teachers on staff when he attended. Black teachers became a reality only after World War II.

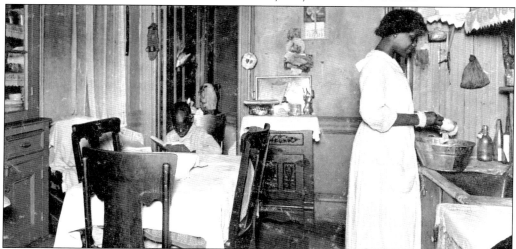

This home scene is all that is needed to tell the story—a dedicated mother committed to her son's education. That was the way many turn-of-the-century immigrant children remembered it in their own homes. Their parents, realizing that time was no longer on their side, hoped to salvage the situation by doing all within their power to see that their children succeeded. That usually meant setting a rigid discipline for studies. One West Indian remembered it this way: "Homework was as necessary to life as breathing."

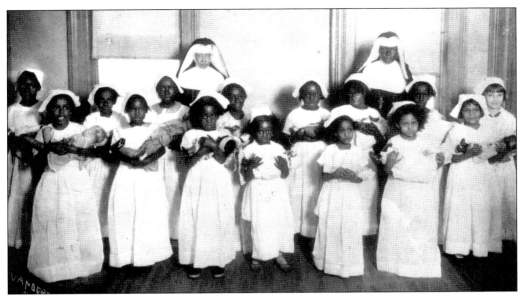

In the early 20th century, role slotting was very common and peculiar to certain groups. Women were mostly expected to have home careers, and many black schoolgirls were trained in housework disciplines (sometimes disguised as nursing) that would prepare them for employment as domestics and nannies. In this regard, the Catholic schools were no different than the others. These juvenile students are been taught to care for infants, and the white dolls some are holding suggest that the emphasis was not necessarily on the care of their own (anticipated) children.

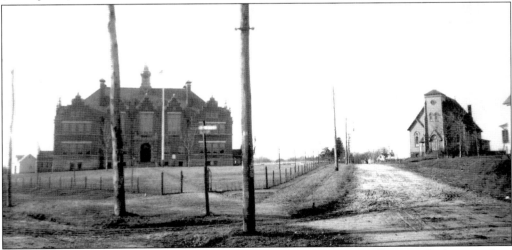

When Public School No. 34 was built c. 1900, the town of Queens Village was little more than a concept, with far more farm space than residential. From the size of the school, however, it was clear that large growth was anticipated. This picture, taken at the Springfield Boulevard and Hollis Avenue intersection in 1915, shows few other buildings but the St. Joachim Roman Catholic church to the right. Since then, a rash of postwar housing developments filled in the empty spaces south and west of the church. The neighborhood began its racial transformation to predominantly black in the 1970s. Except for an addition to its eastern wall, the school has remained the same.

From its modest beginning in a few renovated family buildings purchased on Jefferson Avenue in 1923, the St. Peter Elementary School would grow into a first-rate facility, moving into new quarters in an elegant building just two decades later, despite the community's struggle to stay viable. With many pillars of the community lost, either through death or flight to the suburbs, the faithful would commit themselves to preserving the parish. In this 1972 graduation photograph are some of the grandchildren of the immigrants who made it all happen.

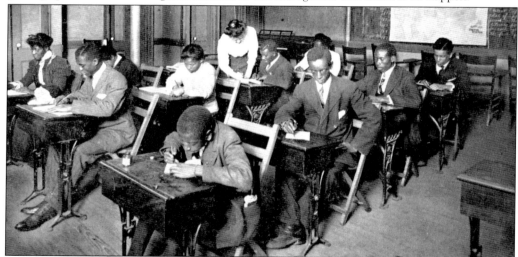

This is the Henrietta night school, but it could just as easily have been Andrea Clark's. The immigrant Jamaican started a night school in Harlem in 1922 to teach adult immigrants the rudiments of clerical work—typing, shorthand, bookkeeping, and so on. In a few short years, Clark was doing a brisk business with those blacks who wanted "shirt and tie" jobs. This was a distinction more common to West Indians than to Americans. From the relatively advanced age of the students in the picture, it might not be unreasonable to conclude they are primarily immigrants.

Two of the most dreaded words any West Indian parents could expect to hear from a school counselor concerning their child's education were "trade school." After World War II, it was generally felt that most blacks were equipped for little else than manual labor or some similar type of industrial work—something where the hands were more applicable than the brain. This, naturally, went against the grain of the West Indians, who regarded the trade schools as places you commit those with mental deficiencies.

"It is a popular misconception that the West Indians left Harlem solely because they wanted to own homes. It is not as simple as that," said McDonald Holder, an eminent political strategist. By 1950, attitudes had changed. Many, including Holder's niece, had abandoned Harlem because they felt it was no longer safe to raise children there. Here we see a manifestation of this in a symbolic pose by a student on his way to school with his books and a knife. The weapon was supposedly to defend himself.

This 1940 photograph of St. Peter Claver Elementary shows what appears to be a coeducational school, but that was not entirely the case. Boys and girls were not taught together in the same classes, and some subjects were distinctly gender oriented. However, what the photograph does reveal is a contented group of kids who seem to relish in the attention given them. The school was committed, above all, to the inculcation of self-esteem and dignity of the individual.

They are hardly recognizable in this picture, but one of these budding basketball players of the St. Margaret Episcopal school grew up to become an army general and secretary of state. Another became a revered champion of African American causes. Kneeling at left is the future black nationalist Elombe Brath. Standing fourth from the left is future joint chief of staff of the U.S. military Colin Powell. The parents of both hailed from the British West Indies.

By the time future secretary of state Colin Powell entered Morris High School (shown here), he had come to a curious awareness—most of his white friends from his elementary school days were no longer around, and those few who had remained had drifted apart. Also, his effort to join them at the elite Bronx High School of Science was not supported by his former school counselor. Nevertheless, the Puerto Ricans and blacks who took their place made his passage to adulthood a pleasant one.

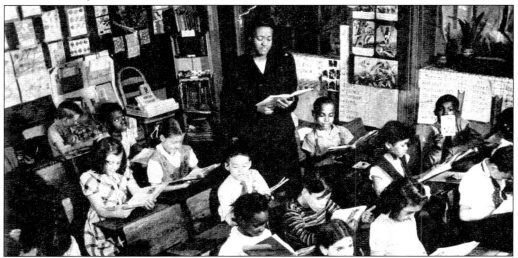

This teacher is fortunate, for it is 1947 and she is able to obtain a job in her chosen profession. Just a few short years earlier, her task would have been a great deal more complicated. Dr. Muriel Petioni remembered how it was prior to the war, when many of her college classmates were unable to secure positions in their area of pursuit upon graduating. The war, however, forced many whites into defense work, freeing up some professional positions and creating some openings for blacks.

The old Harriet Beecher Stowe public school, at West 136th Street in Manhattan, is shown in a recent photograph. Dr. Muriel Petioni attended the school in the 1920s, when it was an all-girls high school with an integrated student body and a citywide reputation for excellence. Even then, many of its graduates went on to distinguish themselves in the professions. Its alumni list includes doctors, lawyers, directors of agencies, leaders of commercial establishments, and even a judge.

City College in the 1930s was a institution of stellar academic reputation. It was established to educate those children of poor European immigrants who were gifted but could not afford the more expensive private colleges. Although it was a tuition-free institution, many of the West Indian candidates, even those with Senior Cambridge certificates, were unable to gain admission to the day program. They were consequently forced to settle for night courses, which made their baccalaureate pursuit all the more difficult. In addition, it was harder to get the necessary recommendation to apply to professional school.

The Medgar Evers College was established in Brooklyn in 1969 through the effort of several community leaders, some of whom were black and some of whom were white members of the Hasidic Jewish community. The idea for the college was certainly about education, but there was a secondary purpose, which was about funneling city and state funds through to antipoverty community projects. The college is situated in Crown Heights, and the student body is predominantly Caribbean. In 1986, a new campus was built on Bedford Avenue.

Dr. George Irish, director of the Caribbean Research Center, seems to be making a point at one of his board meetings. The center was established in 1984 at the urging of the Caribbean American community, who felt the issue of their growing population were not being adequately addressed. The center is housed on the campus of the Medgar Evers College in central Brooklyn. In addition to providing resource material on the community, it also conducts studies.

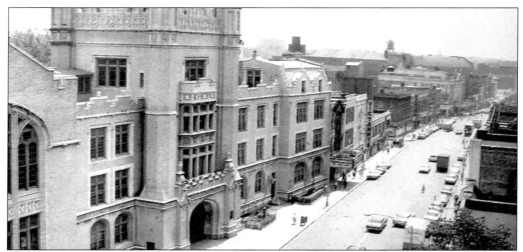

Erasmus Hall High School, on Flatbush Avenue in Brooklyn off Church Avenue, is one of the city's most venerable institutions of learning. The original edifice, a wooden structure built in 1786 by the Dutch Reform Church, is still housed in school's courtyard. The school was eventually taken over by the New York City Board of Education and remodeled. In its long history, it has provided an education to those of various nationalities and now principally serves the large Caribbean American population of the district.

This symbolic photograph shows the imposed facade of the old Boys' High School towering over its newly built replacement in a somewhat protective manner. The older building gloried in a prewar era, when its student body was made up of mostly eastern European Jews and southern Italians, and produced many notable scholars. By the 1980s, however, the student body was virtually black, and the school had become a revolving door for principals who were unable to cope with its chaos. In the last decade, under the austere and dynamic leadership of its present principal, Dr. Frank Mehan, the school has rebounded to something reminiscent of its past.

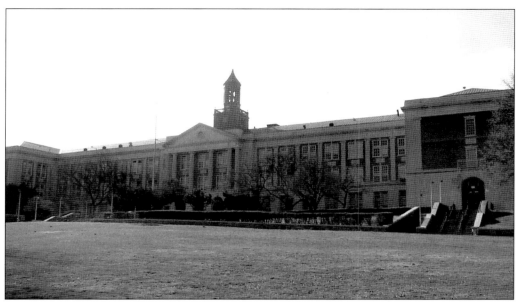

The school up on the Hill, Jamaica High School, was the site of an interesting experiment in education in the 1960s. Already a highly regarded secondary institution of learning, with a sizable Jewish student body, the school in the 1960s began earnest outreach to gifted minority students of poor families, many of whom lived in the predominantly black section south of Archer Avenue. The idea, according to one of its former students, was to exploit all of the available talent of the nation in light of the Soviet technological triumph with its space program in placing *Sputnik* in orbit.

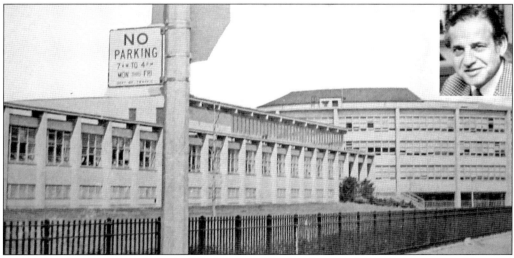

By the late 1970s, most whites had fled Crown Heights, leaving behind a determined band of Hasidic Jews. The George Wingate High School, an experimental institution that graduated its first class in 1967, saw its educational excellence plummet as the student body went from a select group of middle-class whites and blacks to a mostly post-1965 impoverished immigrant body, many of whom spoke Creole French as their first language. By the late 1980s, however, under the leadership of Dr. Robert Schain, the school regained some of its footing, attracting national attention for its orderliness.

It is referred to by some parents as the school that Sam built. In these instances, Sam was the former pastor of Brooklyn's St. Mark's Episcopal church and the founder of its elementary school. A product of the British grammar school system in his native Guyana, principal Heron Sam incorporated many of its features into his school, insisting upon strict discipline and the wearing of school uniforms. Even in his absence, the school continues to be one of the most sought after by the community's parents.

By the 1970s and 1980s, the turn-of-century West Indian immigrants were being represented by their second- and third-generation American-born descendants. These were no longer West Indians but Americans, as singer Richie Havens so aptly described it: "We fought to claim our new American identity, one that was based on a different culture from our parents." Some lost all connections to their West Indian heritage, and others tried to hold on. With the passage of time, however, all the qualities that made their antecedents so special were all but lost to them. By the 1990s, educators were experimenting with all kind of novel ideas, such as this preparatory school in Harlem, hoping to reignite the spark of excellence.

Six

RELIGION

Religion has always been central to the conduct of blacks in the Americas. In the Caribbean, perhaps more so than in the United States, spirituality in its organized form was regarded as an essence of civility and social bearing. Convinced of this, the newly liberated blacks began the move to join the mainstream religions of the masters and former masters, more out of ambition than out of moral suasion.

The blacks who attended the services of the white establishment churches were expected to conduct themselves in every respect as their white co-religionist—and for the most part, they did. Discontentment and resentment usually gave way to resignation and stoicism at the church's entrance. Religious services then, as now, are staid, low-keyed ceremonies, shrouded in solemnity. The rituals are performed with a choreographic consistency that has remained loyal to traditions, and the sermons are enunciated with a muted exhortation to righteousness. The connection between the presiding minister and his audience is usually one of reverence, as opposed to psychic. This is true of all major European established denominations, whether they be of Catholic or Protestant orientations.

The West Indians, on their way to the United States, brought their religious practices and customs to the black communities, not entirely out of commitment of faith but out of secular expediency as well. Clearly, they preferred the staidness of the Catholic, Episcopalian (Anglican), and Wesleyan (Methodist) faiths to the raw catharsis and emotional venting of the Pentecostal and Southern Baptist religions. Their preference, interestingly, had social implications that went beyond the mere intent of worship, in that it suggested a hierarchy of class, which was quite often lost on the black American public, with their major emphasis upon caste. Even then, the process of immigration tilted toward the brightest and the best. That is, it favored (if inadvertently) the more educated and sophisticated West Indians who usually embraced the organized European religions and worship. Moreover, only those with some semblance of means were able to participate in church affairs with any degree of regularity. The lesser educated, lower-class immigrants preferred worship in the Pentecostal religions, where a psychic channel between the minister and the audience is essential to the conduct of the service.

That the earlier West Indians were so overwhelmingly members of these established religions and exhibited proclivities for sedate worship reasonably suggests that they were mostly from the upper stations, or aspired to them. This being said, however, is not to suggest that there were not other alternative religions favored by the West Indians of means, the most common being the Seventh Day Adventist and the Moravian. At the other extreme were the religions that were admixtures of African paganism and Christian theology.

Interestingly, the tendency of West Indians to favor the European paradigm of worship had its downside for the African American, as it was devoid of fraternal cohesion. Civil liberties may have been spoken about on the streets, but it was only the churches that were in the position to implement them. To the consternation of the earlier West Indian immigrants, it was the Southern Baptists, with their sense of victimization, who spawned the necessary institutions of political and financial empowerment of blacks.

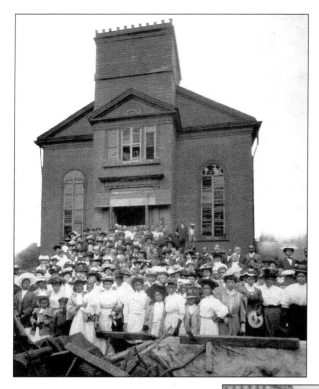

Before it became arguably the most important black church in New York City, Abyssian Baptist was just another run-of-the-mill house of worship struggling to keep its doors open. In this rare photograph, taken in 1907, a flock of its faithfuls assemble before the church, then located in Greenwich Village. Not long after, the church got a new pastor, Rev. Adam Clayton Powell Sr., and moved to mid-Manhattan on the West Side and then on to Harlem at its present West 138th Street location.

The Plymouth Episcopal church in prominent Brooklyn Heights has secured a page in history by being a safe house for the Underground Railroad. It was sufficiently distanced from the Fleet Street slum of Fort Greene to give it respectability but was near enough to share vicariously in the pains of the poor and powerlessness. Henry Ward Beecher preached at Plymouth, and it has been whispered that his inspiration came from the poverty he saw around him. Today, both church and man are remembered for their compassion and charity.

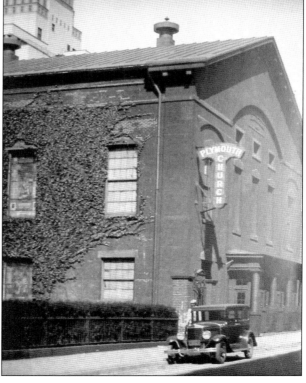

The venerable Roman Catholic church St. Benedict the Moor of Manhattan is pictured as it appeared in 1936. The church, located on West 53rd Street, was one of the few integrated houses of worship of a major denomination at the beginning of the 20th century. It was renowned as a house of refuge for blacks, St. Benedict being the patron saint of blacks. In a time before social security and other social service agencies, the church customarily provided a means of existence for those who had none. It was remembered fondly by the Caribbeans who lived in the Tenderloin and San Juan Hill neighborhoods during the period.

St. Philip's Episcopal in Harlem is pictured in 1930. The church was originally located on West 53rd Street and was an early favorite of the West Indians of the Tenderloin and San Juan Hill. In 1909, St. Philip's sold its midtown properties and moved to Harlem. Increasingly business-oriented, it soon purchased a row of tenement buildings on West 135th Street and began to draw the ire of a segment of the black community, who accused the church of conducting bad business practices and acting like an abusive landlord. This would cause further erosion of the congregation.

St. Peter Claver Roman Catholic is shown as it appeared not long after it had been converted into a church. Originally a warehouse, the building was bought in 1921 by a group of mostly black West Indians led by Rev. Bernard Quinn (inset). Encouraged by Msgr. John Belford (pastor of nearby Nativity Roman Catholic), who had grown fearful of the growing number of blacks in his church, Quinn established the parish of St. Peter Claver specifically to serve blacks. It thus became, in essence, Brooklyn's first black Roman Catholic church. Quinn died prematurely at the age of 53.

In 1914, few blacks attended St. Mary's, on the corner of Parsons Bouledvard and 89th Avenue. Mostly, they would be persuaded to attend St. Benedict, several blocks away, which was billed as a black ministry. In 1927, the old church was torn down and a new one (called Presentation) was erected on the site. With a changing population, Presentation became more inclined to black worshipers and actively sought their participation. Today, its membership is almost entirely black and predominantly Caribbean.

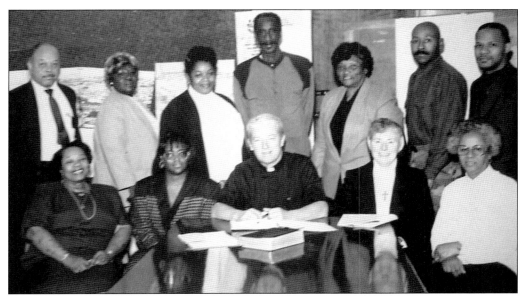

Although women have always been the most committed and loyal followers of religion, they were seldom given more than a secondary role in the church. Most committees were headed by men, even those that relied heavily upon women's participation. By the 1960s, however, some of that began to change with civil agitation by women groups. This resulted in women moving into positions of influence hitherto unattainable to them. Pictured is a St. Peter Claver committee that was once dominated by males and is now amply represented by women.

Certainly not the oldest nor the grandest, the Hanson Place Seventh Day Adventist Church perhaps comes closer to representing the ethnic and social panoply of the Caribbean community than any of its sister organizations. Relatively new to the ecclesiastical constellation, it has been making dynamic inroads into the Caribbean community at the expense of the other established churches. The Hanson Place congregation was established as a charter member in 1958 and moved to its present location in 1963 with the purchase of the Hanson Baptist Church.

St. Cyprian Episcopal Church, pastored by Virginian Rev. John H. Johnson, was a favorite of the immigrant West Indians of the Tenderloin during the first quarter of the 20th century. After his father's death, the younger Johnson moved the ministry to Harlem into the sister church of St. Martin, which he founded in 1928. The second-generation West Indian Americans followed him uptown, where they continue to loyally support his ministry. St. Martin Episcopal, it was said, had "the highest density of middle class West-Indian Americans as congregants anywhere in the City." The church has changed very little since this photograph was taken in the 1950s.

Still a very potent social force in the Harlem community, the St. Martin Episcopal congregation is now pastored by a third-generation Johnson. Many of the West Indian parishioners who supported the senior Johnson have since departed the community, and their children have shown a proclivity for suburban life. A sufficient number of the older generation has remained to keep the church going, as is evident in this 1976 photograph.

The Hanson Methodist Church, at the corner of St. Felix Street, is truly one of the architectural gems of Brooklyn. Although it was just a stone's throw away from a budding black community at Myrtle Avenue in the early 20th century, there are no records that the church ever made any outreach to the people of the community during this time. However, by the end of the Great Depression, several blacks had been admitted as members. The West Indian Protective Service also maintained an office on the block.

Members of the Hanson Methodist Church are gathered in 1986. The group represents one of the standing committees that advise and assist in the running of the church. At the time of the photograph, virtually the entire membership was black, which was a far cry from five decades previous, when the reverse was true. Although blacks have always lived within the neighborhood, it was not until after World War II before their presence in the church became conspicuous. The church is now pastored by the West Indian Rev. Patrick Perrin.

Not until Constance Baker Motley and Shirley Chisholm began defining the role for black women in New York politics in the 1960s did the community become a force to be reckoned with. Since then, blacks have dramatically increased their representation in the various legislatures, benefiting several Caribbean aspirants. Here we see city council member Una Clarke and state assemblywoman Pauline Cummings sharing a light moment with Lorna Neblett, a businesswoman from Guyana.

The Lady of Victory Roman Catholic in Bedford-Stuyvesant, one of the better-known churches, did not develop a sensitivity for its black parishioners until the second half of the 20th century. Many of the earlier West Indians trying to attend were politely turned away with the suggestion that they would be better off at black St. Peter Claver. Ironically, the first black pastor, Martin Carter, received a less than cordial reception by the West Indian parishioners when he took over from a white priest. Today, that attitude no longer exists. Shown in this 1977 photograph is one of its committees.

According to anthropologist Andre Matraux, Haitian voodoo is "nothing more than a conglomeration of beliefs and rites of African origin, which have been closely mixed with Catholic practice." Although the name conjures up images of evil spells and demonic rituals, in reality it is more to the contrary, offering hope and cure to those who perceive themselves afflicted. In its softer form, voodoo is not unlike any Christian religion, bringing salvation to its worshipers. Here we see a high priestess (Mambo) performing one of her ceremonial rituals in an exhibition akin to religious mass. Note the young girls in the audience.

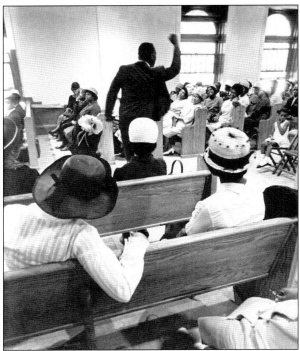

The major difference between the West Indian–oriented churches and their American counterparts was the method of preaching and worshiping. The blacks of America favored the emotion-venting sermons and homilies of their ministers, which invited psychic participation by the congregants. The West Indians, on the other hand, preferred the more sedate worship of their former European masters, believing it is somewhat improper to put one's passion on display in so public a place.

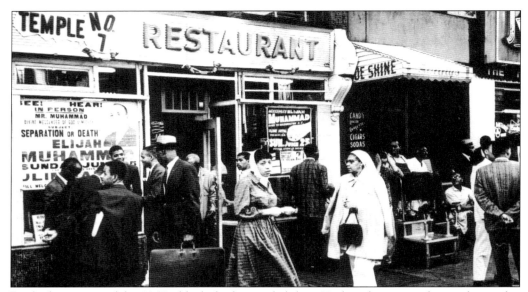

By the beginning of the 1960s, blacks had extended their Harlem domain to the northern edge of Central Park, with 116th Street at Lenox Avenue acquiring the same kind of prominence to black activism as 135th Street was to earlier generations. However, the style had changed if not the message, and much credit went to a young charismatic minister of the Nation of Islam called Malcolm X. Here we see a gathering of Moslem men and women in front of temple No. 7, either entering or leaving worship. Many second- and third-generation Caribbean Americans would answer the call to Islam.

St. Margaret Episcopal was the church of young Colin Powell and Elombe Brath. The church was popular with the immigrant Caribbean families who began settling the borough in force in the days leading up to World War II and immediately after. However, like early West Indian society, it had its own social divisions and interplays based primarily upon a gradient of color. These divisions were usually on display after mass when the different groups would gather to chat.

Seven

LEISURE

A society in transition takes with it not just its hopes but its habits as well. Caribbeans moving to the North American mainland brought with them their traditions and continued to indulge in many of the pastimes of their erstwhile countries. Some of these expressions took on a significance that transcended their leisurely purpose, appending political vehicles as a statement of purpose, as has been the case of the West Indian carnival. The carnival, a celebratory form that eventually found its way into the United States, came into being during the times of slavery when the plantation management would give time off to the slaves to amuse themselves at the end of the harvesting season. This occasion found form in a masquerade in which the revelers would don colorful costumes or paint themselves up, pretending to be something other than what they were—either exotic or demonic. The display would be conducted with festive marches and parades, usually to the accompaniment of indigenous music provided by musicians on a variety of homemade instruments. These instruments varied from hollowed-out bamboo staffs to the sunken surface of empty oil drums. Carnival, or *mas,* has gradually become a staple of the American leisure pastime. Unlike the Caribbean, where it is celebrated on the week preceding Lent, it is usually held on Labor Day in the United States. As the event spreads to other cities, it is increasingly being commemorated on any date that is most convenient to the municipality and sponsors.

Other popular forms of Caribbean entertainment are the anniversary balls, which until recently were undertaken to commemorate some important event, usually the anniversary of the sitting monarch of their colonial government or, in the case of the French speakers, Bastile Day or Haiti's independence. In recent times, the purpose has changed with the independence of many of these nations, though not the occasion—Caribbeans still jump at every opportunity to celebrate. Music concerts held during the warm months of summer are for many the most anticipated events of the year. They often feature performers of international renown, such as the late reggae artist Bob Marley and the Calypso King, Mighty Sparrow.

Sporting events also provide an outlet for leisure. Cricket continues to be a popular pastime among young men, who improvise a playing field on any empty lot than can be found. On the female side, the popular sporting event is the netball tournaments. The game is very similar to basketball, with the only perceptible difference being that the ball is not allowed to touch the surface of the court. Tournaments are usually organized and held during the summer but so far have failed to attract any significant following. Much more recognized is the game of soccer, which is now played at the secondary and college level and offers the more talented players the chance to play nationally or internationally.

With a spawning of American generations, some of these entertainment activities have given way to the domestic types. Baseball and football are just as popular in some immigrant communities as their national sports are, and the names of Patrick Ewing and Orlando Cepeda are just as known as any of those of the traditional sports stars. In the performing arts, Caribbean Americans are also well represented with such people as Sidney Poitier, Harry Belafonte, Esther Rolle, and a slew of others who are making—or have made—names for themselves on the large and small screens.

Although recognized as a black Bahamian, Bert Williams was so light of complexion that he had to darken his face when doing his comedic skit for his vaudeville audience in the early 20th century. So impressive were his talents that he would regularly appear on Broadway at a time when the only presence of blacks was as stage hands. He is pictured with his sidekick, George Walker, who died prematurely. Williams went to star in the Ziegfeld Follies for 11 years while simultaneously writing and producing plays.

Heralded as one of the world's greatest amusement parks, Coney Island regularly attracted in excess of a million visitors on any summer weekend day, as is evidently the case in this 1930 photograph. The park was a favorite of a great many immigrant West Indians, who were accustomed to being surrounded by the ocean in their island homes. Moreover, Coney Island did not exhibit the sort of overt discrimination practiced by many of the other popular beaches and, in addition, offered a great variety of gaming activities.

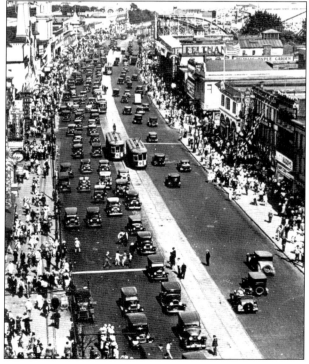

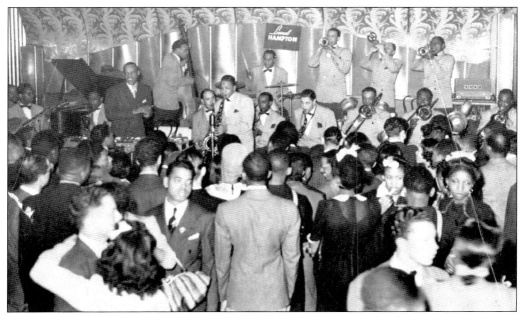

Jazz was not like Calypso or Ska, but it was Americana, and the children of the immigrants felt it to be more their music than the island music of their parents. Their attraction to it caused them to frequent such clubs as Small Paradise, Connie's Inn, and the Savoy ballroom to see the great jazz musicians and dance to their music. This photograph shows what was a typical Saturday night at the Savoy Ballroom, with an enthusiastic crowd listening and dancing to the Lionel Hampton Orchestra.

In 1953, when this picture of the dancing couple at the Savoy Ballroom was taken, the country was in the midst of the postwar boom. It was also the time that Mahmud Ramza, Boysie Atwell, future congressional member Shirley Chisholm, and other second-generation Caribbeans coming of age were making seminal weekend visits to the ballroom to do their thing on the dance floor. By the 1960s, a new consciousness was aroused by the civil rights struggle, and the Savoy quietly slipped into oblivion.

Before the advent of television and other home entertainment devices, checkers was one of the favorite pastimes of the Caribbean menfolk. The game was very popular in parts of the West Indies and acquired the same status on the sidewalks of New York City's black communities. Because it is a sedentary game, it tended to be more popular with the older men and was preferred by their spouses, who believed it kept them away from the bars and bad habits.

In the congested neighborhoods of the city, some things are natural and unceasing. Using the fire hydrants to cool off during the steamy days of summer is almost as old as the city itself and, moreover, is common to all youths, be they white, black, native, or immigrants. In this view, some youths are turning the hydrants into a massive water shower. This was one of the few infractions for which the police would show tolerance.

Considered by many of his peers to be the greatest black documentary filmmaker, William Greaves started out as an actor, having studied under the legendary tutor Lee Strasberg. Born during the Great Depression to immigrant Barbadian parents, he did not follow the great migration of West Indians out of Harlem but remained in Manhattan, where he completed his studies at City College. He is pictured directing one of his films sometime in the 1960s. Among his many credits are the PBS releases *From These Roots*, *The Marijuana Affair*, and *The Ralph Bunche Story*.

Sidney Poitier first came to the critics' attention for his part in the Lorraine Hannesbury play *A Raisin in the Sun* (later a movie). In the play, Poitier portrays a young black man in New York City confronted by all of the obstacles and negativism of racism but determined not to be defeated by them. In this instance, it was art imitating life—his life. He is shown with his costars, Ruby Dee (left), Claudia O'Neill (center), Diana Sanders. The young boy to the left is unidentified.

When it debuted in 1974, *Good Times* rapidly rose to the top of the heap of the prime time sitcoms on the strength of its two stars—Jimmy Walker, the flip, irreverent son, and Esther Rolle, the devoted, good-natured mother. Stardom, however, did not come easily for Bahamian American Rolle, who candidly admitted that with her oversize physique and not-too-perfect face, she was not made of the stuff that causes Hollywood to come knocking. Nevertheless, it was precisely because of how she looked that she was picked for the role.

A "pan man" uses a flute to tune his instrument in a Brooklyn pan yard. When he is satisfied with the result, he will join the other musicians of his steel band. This form of music originated in Trinidad in the 1940s. With the cessation of war leaving a glut of empty oil drums lying around abandoned military facilities, enterprising musicians began turning them into percussion instruments by chiseling out grooves into their surfaces and fashioning the sections into notes with a hammer. The instrument was then referred to as a steel pan.

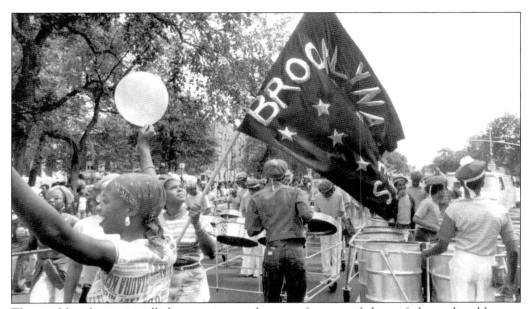

The steel band, as it is called, comprises a selection of empty oil drums fashioned and beaten into musical notes of different pitch. It is a uniquely Caribbean invention and has come to symbolize the region's music. This band, seen at the 1975 West Indian-American Day Carnival, won the first prize in the music competition the day before and has now taken to the road. Because the instruments were too cumbersome to transport on the streets, the bands have all but disappeared from the parade.

Entertainer Harry Belafonte was born in Harlem and was spirited away by his mother to her native Jamaica at an early age to be schooled, returning several years later as an adolescent. Deciding he wanted a career as an actor, he studied under the famous director Erwin Piscator, eventually winning a role in Sean O'Casey's *Juno and the Paycock*, a part that led to his starring role in *Island in the Sun*. Armed with a resonating melodious voice, Belafonte quickly established himself as the leading calypso singer of his generation with the release of the album *Calypso*, which sold more than a million copies.

In 1947, Trinidad native Rufus Goring, director of a local club, got a permit from the city to hold a parade of costumed revelers down Seventh Avenue in Harlem. The event, which was known as the West Indian-American Day Carnival, eventually became an annual spectacle. Twelve years later, Carlos Lezama, who succeeded Goring as director, moved the carnival to Brooklyn Eastern Parkway, following the migration of the West Indians out of Harlem. Goring is pictured a few years before he died.

Pictured is the carnival that almost never was. With tension riding high after a riot stemming from the vehicular death of a young Guyanese boy by a Hasidim and the subsequent killing of a Jewish rabbinical student, city authorities were seriously considering cancelling the annual West Indian-American Day Carnival. Fortunately for these lovely masqueraders, a compromise was struck that included the prohibition of the paraders using a portion of the parkway sidewalk adjacent to the Hasidim headquarters.

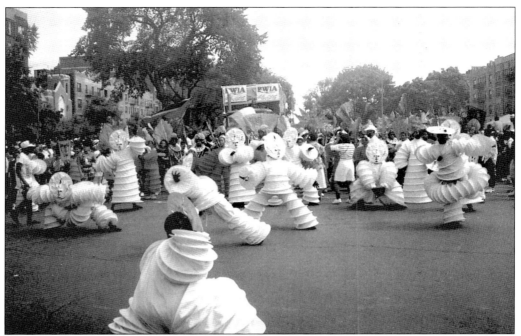

These carnival showpieces are from the creation of Trinidad's nationally renowned costume designer Peter Minshell. The participants can choose to perform individually or as members of a band and are judged for their creativity and originality. The real fun, however, begins on the day of the parade, which in the United States is Labor Day. All the masqueraders take to the street, dancing to the accompaniment of music. These scenes are from the 1990 carnival on Brooklyn's Eastern Parkway. The man to the right is representing himself as a bee, of a type common to his native Trinidad.

Bob Marley's only claim to New York residence is his frequent trips to the city to perform. Yet his influence, which has transcended his music to that of a cultural icon, has been so great upon the black grassroots element that it would be impossible to separate him from the history of black America. Born on the island of Jamaica in 1945, Marley later traveled to England. There, bringing his own innovative style to the folkloric sound of his native Jamaica, he popularized reggae to unimaginable heights on the world stage. He died in 1983 of a brain tumor.

Bob Marley was more than a reggae singer; he was perceived to be a messenger to the poor. For those who were disenfranchised or powerless, his message resonated with hope and righteousness. His music was not intended solely for the wretched but also for the angry. It resonated among all who believe themselves disenfranchised. In death, he has become even larger than he was in life and has grown into a universal cult phenomenon. His mystique is even intriguing to the tot standing beside his mural.

Trinidadian Lew Alcindor (Kareem Abdul Jabbar) of the Los Angeles Lakers and Jamaican-born Patrick Ewing of the New York Knickerbockers battle for the ball. Jabbar was the dominant player in the NBA at the time of this meeting. He soon retired, leaving the field to his younger rival. Ewing, in turn, was challenged by another dominating center, Bahamian Tim Duncan of the San Antonio Spurs. Their stardom has influenced many young West Indians to choose the game over other traditional sports.

Trinidad native Geoffrey Holder—a dancer, choreographer, and director—is all of these and more. As a pitchman for the uncola, he epitomizes the jolly, carefree native for whom life is a joyous journey through a land of fantasy. On the more substantive side, Holder is a committed advocate of the upliftment of people and communities and has lent generously of his time and talent to the promotion of these causes.

Members of a Guyanese cricket club pose on Nassau's Bay Park. As is true of the other former British Caribbean colonies, cricket is a passion with the people of Guyana, and they bring that passion with them to the United States. This club is made up of players of East Indian extraction. Their foreparents were brought to the region as indentured workers by the colonial British. During the summer, the various clubs play each other in tournaments.

It may be the most popular game in the world, but soccer is still relatively unknown in the United States. The early West Indian immigrants who favored the game were discouraged from actively participating because of a lack of playing fields. However, with the increasing interest in the game by the native born, some facilities have been provided in certain West Indian neighborhoods. In this view, two college teams duel for supremacy on a Brooklyn playground.

Eight

PORTRAITS

One famous black photographer candidly confessed that he got into the business of picture taking not because of any recognized aptitude on his part at the time for the profession but rather because a favorite uncle had given him a camera, which in 1911 was a luxury only affordable by the wealthier class.

Coming from the South, he had often visited neighbors' homes and saw pictures of whites hanging on their walls. Although those pictured sometimes bore no resemblance to the occupants, they would nonetheless insist that they were distant relatives. This practice was also common among the many poorer West Indians he was later to befriend in New York City. It took him a while, but he eventually concluded that the possessors were really engaging in a type of fantasy. Having procured the discarded photographs of white employers, they hung them in their homes, claiming relations. This was usually done with the intention of enhancing the stature of the claimant. Although the photographer was empathetic, the discovery of the practice saddened him, for he understood that the poor souls were driven to this behavior in their desperate search for ancestral connection. This could only be understood in the context of history—the abduction of their forebears into slavery had amputated most, if not all, of their familial extensions. Their yearning for an identity that was not tainted by the stigma of slavery had been the principal motivation behind their fanciful indiscretions.

All this gave the photographer the idea that if such people were given the choice of being able to secure their own images, they would prefer them to those of strangers. He was eventually proven right in this assumption, but the changes were gradual, as the cost of procurement of such photographs was so exorbitant that only those blacks who achieved some level of financial secureness were able to have their pictures taken at their behest. It is a fact, long forgotten, that superstition was a part of African thought of the period. This prevented many slaves, or descendants, from having their pictures taken in the belief that such would also capture and imprison their spirits. This belief lingered in America among the lower class at the turn of the century. Yet it was rather ironic that among the most frequently photographed of the black public were the poorest and the most defenseless, whose images were perfunctorily taken by the police on occasions of apprehension, for their criminal gallery—no matter how petty the offense. The poorer immigrants were somewhat more fortunate than their American counterparts, as the occasion for their portraits were usually for the purpose of travel and not for police business. For some, these passport photographs were their only connection to the past. This irony was not missed by the said photographer, who was determined to alleviate the injustice of circumstance by presenting as many positive images as he could of the black public. The ethnic East Indians who arrived much later were spared most of these indignities, as the path toward assimilation would be less obstructed.

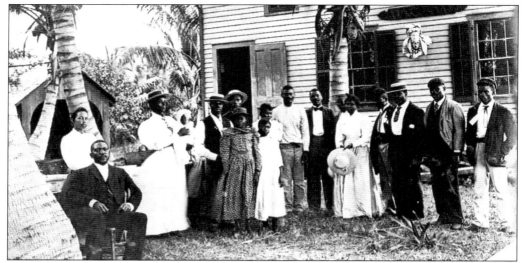

One of the first Caribbean groups to establish themselves in New York City were the Bahamians. Their historical route is somewhat convoluted, not to mention unusual. Many went from America to the Caribbean and then back to America, having willingly followed their vanquished Federalist masters into exile after the American Revolutionary war. They returned to the United States many years and many generations later as voluntary free immigrants, settling along the eastern seaboard. These immigrants are seen at a 1886 gathering in Florida's Cotton Grove, their jump-off community.

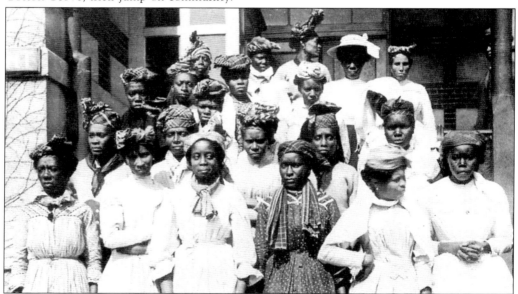

New arrivals are pictured at Ellis Island in 1911. These women from the French West Indian island of Guadeloupe came as sponsorees. At the beginning of the 20th century, many of New York's wealthier residents were of French extraction and preferred having domestics that at least shared something of their culture. The women shown in the picture, however, may not have necessarily been attired in this fashion on arrival. This particular photographer, with an eye for posterity, insisted upon having all new immigrants dressed in their native attire before having their pictures taken.

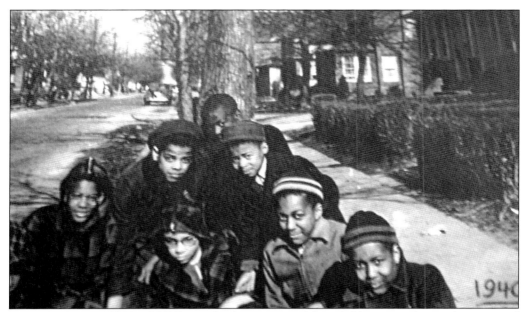

In 1940, 12-year-old Lloyd Williams (back row, second from left) got together with a group of friends to take this picture in the Queens neighborhood of what was then known as Merritt Park. Children of West Indian and American families, they lived carefree and harmonious lives in their modest community, sheltered from the conflicts and turmoil that racked the black communities of the inner city. This amiable coexistence of Americans and West Indians was unusual for the times.

To many of the city's blacks, Sunday was always the best part of the week. "The young men and women would dress in their finest clothes and stroll down the avenues after they left church," remembered Vernon Small, who indulged in the custom as a young man. The newer immigrants, not yet acclimated, would dress colorfully. In this photograph, young adults are enjoying the company of each other on a sunny afternoon stroll on 125th Street sometime during the 1940s.

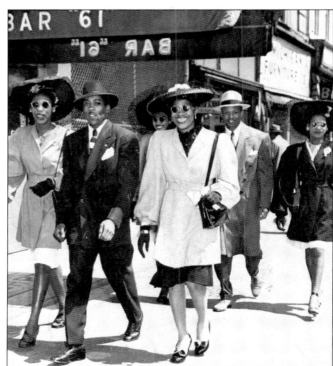

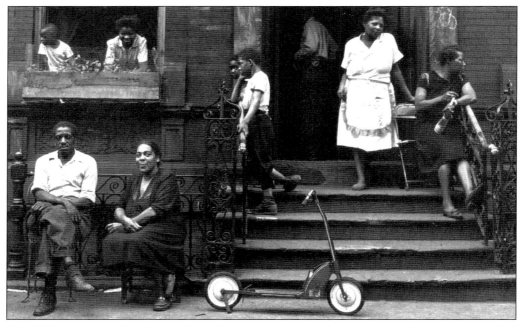

This picture, taken in 1950, shows the old and the new of the ethnic Caribbean generations. There are three generations represented in the photograph, although not necessarily of the same family. The two people sitting on the bench on the sidewalk have been recognized as immigrants who may have entered the country before 1930. The woman in white before the entrance is young enough to be their daughter and possibly the mother of the children on the stoop and framed in the window.

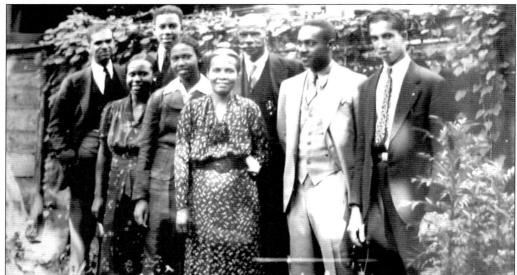

Few Caribbean American families can boast of greater results in their pursuit of the American dream than the Petionis. At a time when blacks counted success in just being able to acquire a high school education, this family of Trinidadian descent was producing medical doctors at an unheard-of rate. In this view, taken c. 1930, there are two present and three future doctors. Charles Petioni, the patriarch, is seen at center in the back, and Muriel is second from the left.

Few others have had a greater impact on New York City politics than J. Raymond Jones, also known as the Silver Fox. Contented to be a behind-the-scenes player, Jones was responsible for the successful careers of such politicians as former mayor David Dinkins; former New York secretary of state Basil Patterson; and Manhattan borough presidents Constance Baker Motley, Hulan Jack, and Percy Sutton. Jones's life, however, is no fairy tale. Born to a callous mother with whom he eventually became estranged, Jones had to use all his wits and energy to achieve his success.

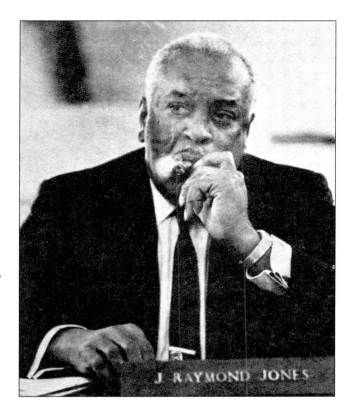

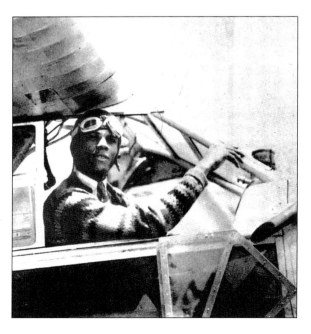

Hubert Fauntleroy Julian (alias, Colonel Julian) was known as the Black Eagle. A notorious self-promoter and supreme egotist, he operated so much in the shadow that even the most diligent researchers are unable to get a grip on the real man. A native of Trinidad (or Guyana), he so convinced the New York Times newspaper of his importance that it assigned a reporter to cover his exploits in Ethiopia while leading that nation's air force in battle against the invading Italians. He claimed among his friends Pres. Franklin Delano Roosevelt and Edsel Ford.

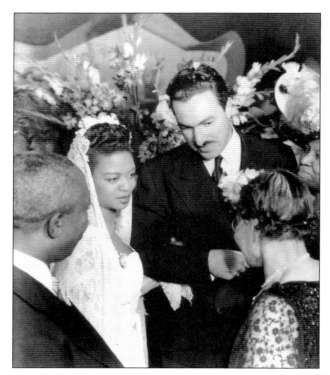

Adam Clayton Powell, in addition to being the consummate black politician of his era, got along famously with the ladies. One female admirer was heard to coo, "Women were just attracted to his good looks." In 1945, he married renowned concert pianist Hazel Scott, a native of Trinidad. Some said the marriage was about love, but a biographer of Powell insisted it was about politics. Journalist Wil Haygood said that Powell saw the marriage as cementing a core of West Indian constituents who were among the most dedicated of voters.

It is little known that Claude McKay, the Jamaican-born writer, gave voice to Prime Minister Winston Churchill in Britain's moment of crisis during its struggle with Nazi Germany. In quoting McKay's poem "If We Must Die," Churchill was able to rally his countrymen to carry on to final victory. McKay wrote not only fine poetry but also fiction. His bestselling book *Home to Harlem* was seen as the first major breakthrough for black writers and set the stage for the likes of Richard Wright and Zora Neale Hurston.

Louis Farrakhan (née Walcott) was recruited into the Black Muslim by Malcolm X. They had more in common than their interest in Islam—both had parents who came out of the West Indies, a point often made in private when recruiting people of Caribbean heritage to the organization, according to Leonard X. Even this bond, however, could not save their friendship when their commitment to their leader began to clash. The schism eventually caused them to become mortal enemies.

Ernest Bowman was quite a shrewd businesswoman, even at a time when woman had not yet come into their own as entrepreneurs. In 1953, when this photograph was taken, she had already established herself in the field of business. She and her husband, John Procope, went on to own several major businesses, including a newspaper and an insurance agency. In 1982, she moved her brokerage firm to Wall Street, becoming among the first blacks to maintain offices in the district.

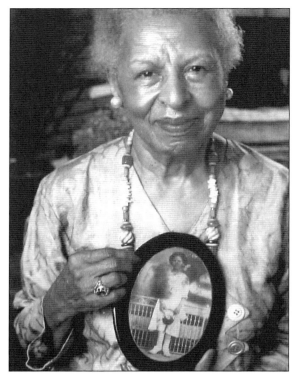

Viola Scott Thomas displays an image of herself as a young girl. In the portrait, she is just a 10-year-old who had the misfortune to be sent back home to Barbados by Ellis Island customs authorities because she had a case of ringworm. Luckily for her, she was allowed to reenter the country once her affliction had been cured. As an adult, she served as the official historian of Manhattan in the administration of then borough president Percy Sutton. She later served as an executive for the advertisement firm AMI.

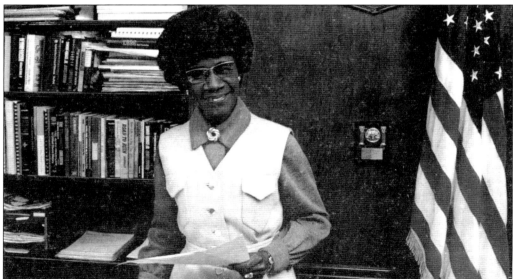

One thing most of those knowledgeable of Shirley Chisholm agree upon is her overpowering personality and insatiable ambition. "Few persons were more consummately suited for politics," one of her associates said of her. Born in Brooklyn to an immigrant West Indian couple, she spent part of her childhood in her parents' country of Barbados. Upon returning to New York City, she attended Brooklyn Girls High School and, later, Brooklyn College. She then moved on to a remarkable career in politics. In 1968, she was elected to the U.S. Congress, becoming the first black woman to serve in that esteemed body.

Sidney Poitier was the first black actor to win the coveted Oscar. Born in Miami to Bahamian parents, Poitier spent virtually his entire boyhood in his parents' country, returning to the United States as an adult. In New York, where he moved to pursue a career in acting, he spent countless hours training his voice in order to lose his West Indian lilt. In 1964, he reached the pinnacle of what would be a stellar career when he was awarded an Oscar for his performance in Lillies of the Field.

By the mid-1960s, the civil rights movement had incited a new consciousness of Afrocentrism among the young. The ethnic Caribbean community was not immune to this influence, which was frequently expressed through faddish lifestyles. In this view, three New York youths are sporting a natural hair style, or Afro, either as a way of making a social statement or in conforming to the times.

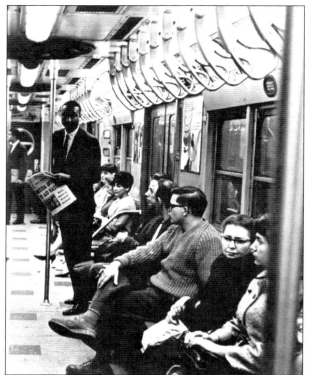

Their expression tells it all. The black man is standing awkwardly in the train, hesitant to take a seat for not wishing to offend those he may sit beside, some of whom are obviously not pleased with his presence. It is very likely he is employed in some sort of administrative position and has purchased a home in a white suburban community. This action does not meet the approval of his fellow commuters. Liberated from their social confines by the 1960s, a great many West Indians purchased homes in white communities.

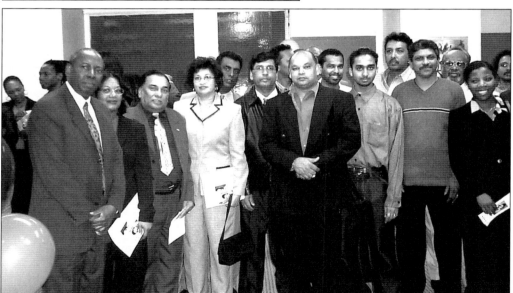

There is always a party going at the Guyana Consulate, this time it is to host a visiting dignitary. With Guyana one of the leading depositories of immigrants to the United States (most of whom live in the New York area), its consulate is always laden with activities. The person who oversees this operation it its longtime consul-general, Brenthold Evans, seen here to the left. With an estimated New York City population of 300,000, most of whom arrived after 1965, Guyanese presence has become conspicuous in all five boroughs.

He has been conferred with just about every honor one can think of, but the one that Dr. Lamuel Stanislaus (right) favors most is that of "Mayor of the Caribbean community." Not without conceit, this Grenadian dentist-turned-diplomat is arguably the most recognized face in Brooklyn's West Indian community. A friend of the high and mighty, he is seen here with the future mayor of Houston, Lee Brown, presiding over parade ceremonies.

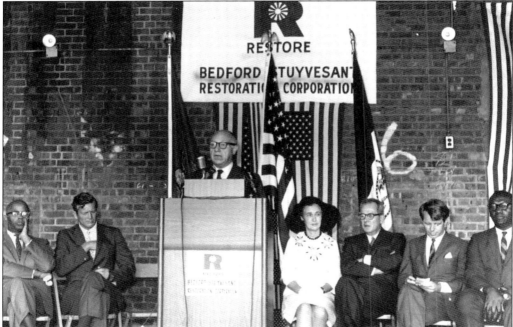

At the opposite end of the picture are two of the most prominent descendants of Barbados: second-generation Tom Jones and first-generation Franklin Thomas. Jones, a mentor of former Congresswoman Shirley Chisholm, headed the Unity Democratic Club before being elected to the state assembly, from which he resigned upon accepting a judgeship. Thomas, a lawyer, was named executive director of the Restoration Corporation, afterwards relinquishing the position to accept the presidency of the Ford Foundation. Also shown in the picture are Sen. Jacob Javits (at podium), Sen. Robert Kennedy, and Mayor John Lindsay.

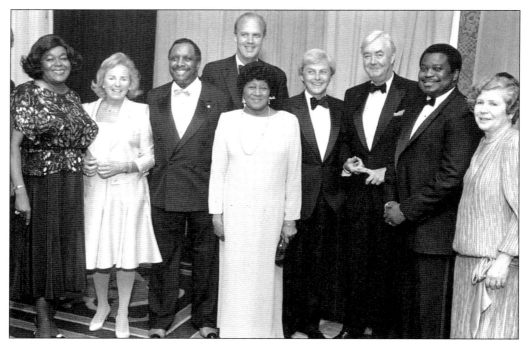

Sadie Feddoes, the longtime columnist for the *Amsterdam News*, has been for many years one of the leading voices on women's issues in the black community. Although a daughter of a Caribbean, she always suppresses her native inclination to articulate on the broader canvass of negritude. To read her column is to discover a treasure of events—past and future. As chairperson of the Restoration Corporation, she has added a touch of culture to its obtuse function of property maintenance. Here, she is seen (left) at one of the organization's fundraising receptions.

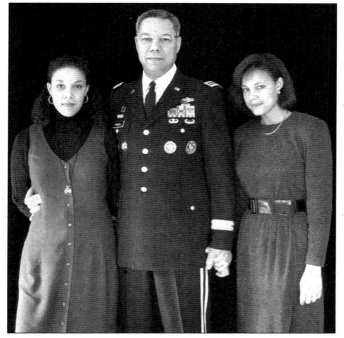

The general is shown with his daughters, Linda (left) and Annemarie. Despite a career filled with serious preoccupations imposed upon it by events of the times, Gen. Colin Powell was always able to find time for his family, especially his children, who were placed under severe stress by the constant uprooting and social dislocation caused by the peripatetic lifestyle of the military. One of the things he has been most proud of is his ability to balance his duty to the military with his obligation to his family.

Jean Michel Basquiat's life was short but full. When the graffiti artist died prematurely at age 28, he was already well on his way to establishing himself as one of America's premier artists. Born in Brooklyn to a Haitian father and Hispanic mother, Basquiat as a teenager attracted the attention of art critic Jeffrey Deitch, after which he was mentored by pop artist icon Andy Warhol. His life was abruptly cut short in 1988 by a drug overdose.

Members of the Caribbean American racial and national diverse community pose in the Brooklyn borough president's office after being honored. Flanking the borough president, Howard Golden (on his right) is the Haitian American Roman Catholic priest Msgr. Rolin Darbouze and the Indo-Guyanese publisher Zamil Shankar, of the newspaper *Daylight*. Opposite are the deputy borough president, Jeanette Gadson, and Kittian professor Edna Hastick.

Rev. Alfred B. Baker had both the distinction of being the founder of the Ebenezer Wesleyan church in Brooklyn's Bedford town and the father of state legislator Bertram Baker. In Brooklyn, where he eventually settled, he established a loyal following to whom he offered spiritual guidance. However, the pull of his beloved Caribbean was too strong, and he returned to his native home of Nevis once his children had reached adulthood.

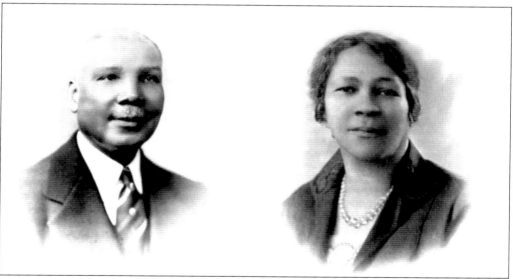

Like so many of their contemporary countrymen, Edwin and Sarah Baker decided to cast their lot for a life abroad, hopped onto a ship, and immigrated to America. Life in this new land did not have the same social equilibrium as his native Nevis, and he had to eke out a living as a poorly paid shipping clerk, an occupation that was much below his education and abilities. Eventually, he was able to purchase his own home, a coveted brownstone on Throop Street—quite an accomplishment in his day.

A pioneer in the city's black politics, Nevisan Bertram Baker (third from left) was elected to the New York State Assembly in 1948, conferring upon himself the distinction of being the first black to represent a Brooklyn district in this legislative body. However, Baker was just following in the footstep of another Nevisan, the American historical icon Alexander Hamilton, who preceded him by some 200 years. An ardent champion of civil rights, Baker sponsored legislation calling for equal treatment in housing and employment for blacks. Shown is Gov. Averell Harriman signing one of his sponsored bills. Second from the left is Roy Wilkins of the NAACP.

Journalist Ron Howell, the maternal great-grandson of Edwin and Sarah Baker and the third American generation, continues the family tradition of civic leadership. With more than 25 years of reporting behind him, he has covered stories in almost every nation of the Caribbean region and met with most of their leaders, including Fidel Castro. A graduate of Yale University and Columbia School of Journalism, he speaks both Spanish and French, in addition to his natural language of English. Shown is an article describing his Persian Gulf War assignment.

Brooklyn Journalist Covers Perisan Gulf War For Newsday

By GEORGE WOODS, JR.

RON HOWELL

Born and raised in Bedford-Stuyvesant area, Ronald O. Howell, who uses the abbreviated first name of "Ron" as a journalist is currently on assignment with Allied Troops in Saudi Arabia as a staff foreign correspondent of NEWSDAY.

The son of Marian and Wilfred Howell, he graduated with honor from Brooklyn Preparatory High School. Having been awarded a Fellowship from The University of Michigan, he is a graduate of Yale University and The School of Journalism of Columbia University. Mr. Howell also studied French at La Sor Bonne in Paris and spent a summer in Santo Domingo studying Spanish.

While a reporter with The Associated Press, Mr. Howell and his family spent approximately two years in Mexico City. In addition to having been a reporter with The Baltimore Evening Sun and The New York Daily News, he has been an Associated Editor with Ebony Magazine.

Harvard Divinity School was an Episcopal priest. His maternal grandfather, the late Honorable Bertram L. Baker was the first Black elected official from Brooklyn to be a member of The New York State Assembly.

In speaking of her son, Mrs. Howell

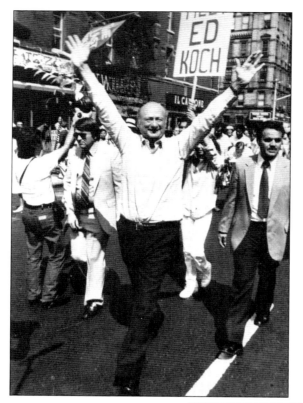

Edward Koch, the 43rd mayor of New York City, was a flamboyant showman. His tenure in city hall, marked by uproarious civil disobedience, was nonetheless very productive. One of his greatest legacies is the Nehemiah project—a house development program in the devastated Brownsville section of Brooklyn that allows low-income minority families to purchase their own homes. He also instituted the office of African American and Caribbean Affairs to deal with all issues concerning the minority community and staffed it with a very able director in the person of James Harding.

He has been adopted by the Trinidad community as one of its own and takes great pride in the distinction. On a more substantive level, it is said no other politician has done as much for Brooklyn Caribbeans than this Jewish former senator, Marty Markowitz. Extraordinarily energetic—and sociable to boot—he is as easily at home on the streets of black Bedford-Stuyvesant as he is in white Bensonhurst. In the fulfillment of a lifelong ambition, he was recently elected Brooklyn's borough president. Here he is seen introducing his deputy, the Caribbean Yvonne Graham.

Hailed as one of the most charismatic politicians of the last half-century, priest and former president Jean Bertand Aristride was not spared the crucible that confronts most Haitian presidential aspirants. Dogged by the communist label because of his liberal views and his embrace by the poor, he attracted powerful enemies who were determined to deny him his most coveted ambition. He is pictured meeting with a delegation of loyal Haitian expatriates, led by community activist Wilson Desir (right), on a trip to New York City in 1988.

Many of the post-1965 Haitians quietly settled in central Brooklyn before branching out to other parts of the city as their financial situation improved. Fiercely independent, they have shown a capacity for business enterprise. Faced with the social realities of American life, many are satisfied to keep their business private and small. Here we see Gaumar Jean-Paul, a modest and unassuming man, standing before his copying firm in Manhattan, which he started in 1989 and runs solely as a means for providing a livelihood for his family.

In 1982, Major Owens replaced Shirley Chisholm as congressman of the increasingly Caribbean district of Crown Heights. A political pragmatist whose heritage is of the South, he has become so adept in the political craft that he was able to easily fend off a challenge by the formidable councilwoman Una Clarke, a onetime protégé, beating her in many of her native Jamaican neighborhoods. Before pursuing politics, Owens worked as a librarian in the Brooklyn system.

At one time in her life, Helen Marshall wondered whether her career would end as it begun—as a teacher. That was before she realized there was a higher calling for which she was well equipped. She later entered politics, successfully running for the 35th Assembly District. Born to immigrant Guyanese parents, Marshall showed leadership qualities at an early age, excelling both at Bronx's Morris High School and Queens College, where she earned a bachelor of arts in education.

Guyanese Paul Lachhu is just one of the post-1965 Caribbeans who have been making a name for themselves. With virtually no financial resources of his own, he was still able to launch the *Caribbean Business Journal*—a glossy-covered broad sheet that focuses on Caribbean businesses—just nine years after arriving in the United States. Today, the journal enjoys an impressive readership of mostly middle class and is considered among the premier journals of its kind.

Pictured are two of the post-1965 West Indian leaders being honored by Brooklyn district attorney Charles Hynes for their contribution to the black community. Dawad Phillips (left) is the longtime editor of the *Daily Challenge*, the city's only black daily. Under his stewardship, the paper has grown to become one of the city's most respected and read alternative papers. James Conolly (right) is a civic activist who is well known in the community for his support of black-oriented causes. The young lady in the center is unidentified.

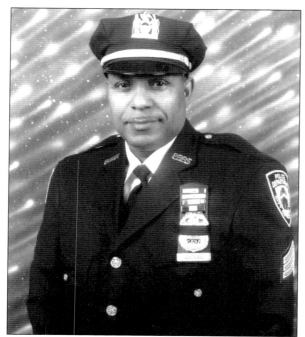

Few other things have spotlighted the police relations with the Caribbean American community more than the brutalization of Haitian immigrant Abner Louima by a police officer. Unfortunately, the incident detracted from the strides made in the police ranks by people of Caribbean designation. One who has been making a name for himself is Haitian American Herve Guiteau. Immigrating to the United States in 1968, Guiteau went on to earn a bachelor of science from Stony Brook University before joining the police force. He now serves as a supervising sergeant in the Brooklyn South command.

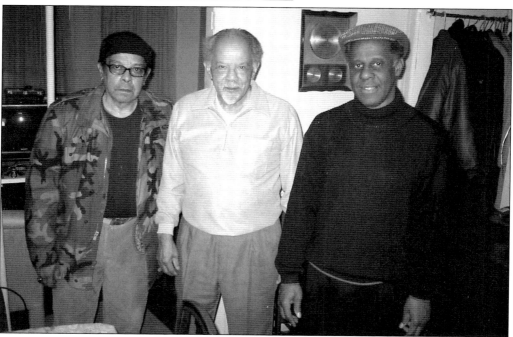

Archivist Duncan Turner (center) is shown with friends in his Queen's Merritt Park home that he has lived in ever since his father bought the property in 1917. Turner, whose sister-in-law is the daughter of the famous black activist Richard B. Moore, remembers the neighborhood when it was little more than a mosquito-infested backwater homestead. Standing at his right is former police sergeant Lloyd Williams, who was born in the house next to Turner's 72 years ago. The pair is being interviewed by the author for the project.